THEN & NOW®

CHATTANOOGA

CHATTANOOGA

William F. Hull

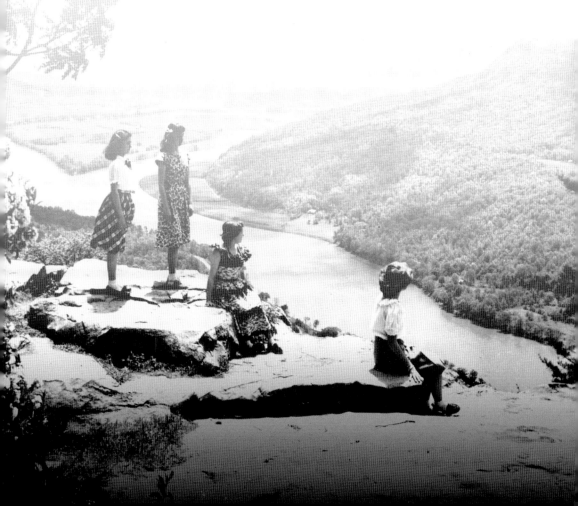

Published by Arcadia Publishing
Charleston, South Carolina

Printed in the United States of America

Library of Congress control number: 2007932429

Then and Now is a registered trademark and is used under license from
Salamander Books Limited

For all general information contact Arcadia Publishing at:
Telephone 843-853-2070
Fax 843-853-0044
E-mail sales@arcadiapublishing.com
For customer service and orders:
Toll-Free 1-888-313-2665

Visit us on the Internet at www.arcadiapublishing.com

For Eleanor

On the Front Cover: Pedestrians on Market Street cross Seventh Street during a downtown workday. Distinctly visible is the Victorian facade of the finely detailed Central Block Building, one of Chattanooga's oldest structures, which was renovated in 2003. Market Street functioned essentially as Chattanooga's main street for generations and still reflects the human scale of architecture that dominates most of the city's pedestrian-friendly downtown. (Courtesy Chattanooga–Hamilton County Bicentennial Library.)

On the Back Cover: Chattanooga was founded on the mighty Tennessee River at Ross's Landing in 1815 by John Ross, the great Cherokee statesman. This photograph of ship building was taken almost 50 years later, when the occupation of Chattanooga by Union troops during the Civil War turned the city into a supply depot for the assault on Atlanta and points south. Numerous trained engineers and skilled craftsman such as these men gave the North a tremendous advantage since they could erect factories and produce armaments for war wherever they were located. (Courtesy Chattanooga–Hamilton County Bicentennial Library.)

CONTENTS

ACKNOWLEDGMENTS

The author wishes to thank the most excellent staff in the local history and genealogy department at the Chattanooga–Hamilton County Bicentennial Library. Your receptive attitude, willing response, and thorough knowledge are constant and always appreciated. Acknowledgment is also extended to Mrs. Minette (Earl A.) Millwood, daughter of the late Paul Heiner. I would like to credit Maury Nicely's fascinating book, *Chattanooga Walking Tour and Historic Guide*, as a resource on several points. And a special thank you is due Nanker Phelge for his inspiration. Most importantly, my gratitude goes to my wife, Eleanor, for her unremitting patience, attentive ear, and critical eye.

All the contemporary photographic images in this book are the work of the author's hand. All historic images are courtesy of the Chattanooga–Hamilton County Bicentennial Library.

INTRODUCTION

Chattanooga, Tennessee, was born on the river. The first settlements from Native American times thousands of unknown years ago made a life by the river's waters at Moccasin Bend and Williams Island. The big river that flows out of the east Tennessee mountains and makes its way past Chattanooga south into Alabama was the lifeblood for farming communities in the early 1800s. Approximately 40 years after the United States became a nation, an energetic Cherokee man named John Ross established a ferry and warehouse on the river at a low place between a bluff and a hill. The name given to the spot was Ross's Landing, and by 1816, travelers trying to cross the irascible river could obtain ferry passage via this transport service to the south side of the Tennessee River. This was important because Ross's Landing was located on the border of the Cherokee Nation; passengers on the north side of the river wanting passage across the river were in the southernmost boundary of Hamilton County, Tennessee, in the United States of America. By the 1820s, river traffic was increasing, mostly in the form of keelboats, which were best suited for travel downstream. Eventually, one steamer, the *Atlas*, did make it to Chattanooga in 1828 after traveling upstream the length of the river. But maneuvering by the federal government and the insistence of Andrew Jackson determined that the small town of Chattanooga would exist without the Cherokee Nation; sadly, these people were removed from their Tennessee homeland to the Oklahoma Territory via the tragic Trail of Tears in 1838.

By the time the nation dissolved into war in 1861, Chattanooga had made a name for itself. Commerce on the river was vigorous, and the Western and Atlantic Railroad from Atlanta had arrived 10 years earlier; now three railroads were already in place, making the hamlet of approximately 2,500 people a target for the rapacious Northern generals. In September 1863, a great struggle at Chickamauga, Georgia, just south of town sent the surprised Federal troops reeling in defeat and back into Chattanooga, where they were besieged by the Confederate armies. For many miserable weeks, the Union army barely survived until Union Gen. Ulysses S. Grant assaulted every Confederate position and opened the way south to Georgia, granting his lieutenant, General Sherman, an opportunity to split the land in two.

It would be 20 years later, in the 1880s, before Chattanooga would rise, this time as an industrial city filled with the sound and soot of foundries and furnaces near the waters of the Tennessee River. Northern capital and cheap Southern labor were an ideal combination for rapid growth. Chattanooga, which was originally connected to Atlanta via commerce more than any place in Tennessee, would come to resemble a city like Birmingham, with its sprawling mills, smokestacks, and hard-working mountain folk—a working-class town. With its strong Appalachian character, religious roots, and easy-going friendliness, Chattanooga can almost be thought of as the biggest town in North Georgia.

For 50 years, Chattanooga grew and prospered. Along the way, the city gathered certain cultural trademarks. The battlefield site of Chickamauga became the first national military park in 1895, inadvertently setting the stage for Chattanooga's tourism future. Two savvy businessmen wrangled an

exclusive deal to bottle a carbonated drink here called Coca-Cola. A bakery salesman got an idea to make a lunch snack known as a Moon Pie. A dedicated spelunker spent hours and hours inside Lookout Mountain and found a waterfall he named for his wife, Ruby. Another mountain resident created a small-scale game that he called Tom Thumb golf, introducing the world to the intricacies of putt-putt. A small hamburger called a Krystal would satisfy hungry stomachs on a Depression-era budget.

By the 1930s, a great transformation lay ahead. The Tennessee River, which rose and shrank unpredictably, had flooded the town on several occasions in the worst way. Franklin Delano Roosevelt saw a solution to this problem and an opportunity to create jobs, electric power, and a better life. The result was the Tennessee Valley Authority, a series of dams built to control the rushing waters of the river that ran through "the Dynamo of Dixie." It was by almost all measures a long-standing success. But by the 1960s, the heavy industry that was the economic base of the city was beginning to stagnate, and the "Scenic City" was getting harder and harder to see as the accumulated smog and frequent air inversions in the river valley prompted veteran television newsman Walter Cronkite to proclaim Chattanooga America's dirtiest city. By 1980, the bad news had only become worse as inflation, suburbanization, and high unemployment were asphyxiating downtown Chattanooga. Although the city had made great strides to renew the air quality and the environment, there was one thing missing: a vision of the future. Through a long series of meetings among both everyday citizens and elected officials, Chattanooga made the decision to return to its origins at the river. In 1992, the opening of the Tennessee Aquarium at a barren Ross's Landing capped years of effort to create a positive and welcoming environment for all people in the heart of downtown. Fifteen years later, the seed that was planted then is blooming fully now.

Some of what remains of this past is included in this book. Chattanooga, like any changing city, has shredded huge sections of its old neighborhoods. Some parts, like the neighborhoods of Fort Wood or North Chattanooga, have survived; others, like Cameron Hill and its west side dwellings, have been obliterated by city fathers eager for urban renewal or simply progress. Some parts of town, like the Bluff View Art District with its splendid Hunter Museum of American Art, are thriving after having been cut in two by road projects 30 years ago. Regardless, Chattanooga is doing well. The city is remembering and reusing its past, and its future looks bright.

RIVER CITY

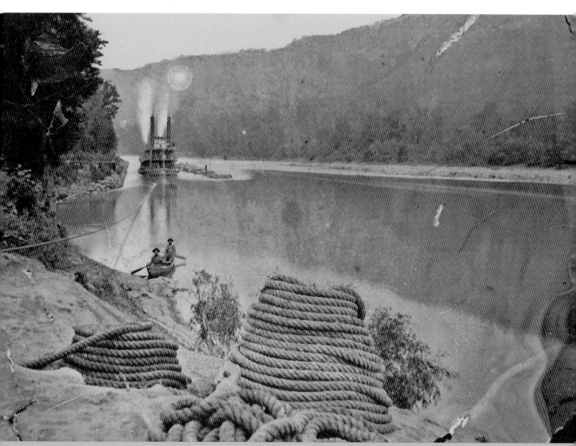

Chattanooga was founded on the Tennessee River, a waterway that could be treacherous to navigate. Here a Union steamboat is guided, or "warped," through a tough piece of the river known as the Narrows as it approaches the town during the Civil War. Laden with supplies for Federal troops occupying Chattanooga, the vessel is dependent on heavy ropes and manpower to keep it free of hidden shoals and unpredictable currents.

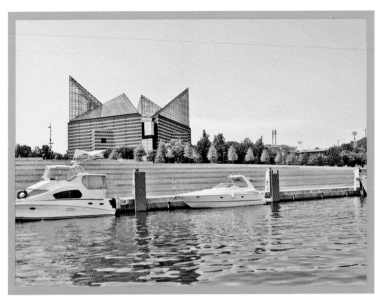

Once, the Union steamboat *Wauhatchie* docked with cargo for thousands of Yankee troops (below) Today the Tennessee Aquarium with its intriguing roofline (above) dominates Ross's Landing. Opened in 1992, the facility was the catalyst for Chattanooga's waterfront revival.

Nearby, steps and expanses of green space slope down to the riverbank, a magnetic site for summer gatherings. To the right is part of Cameron Hill, which over the years has been lowered from repeated building projects.

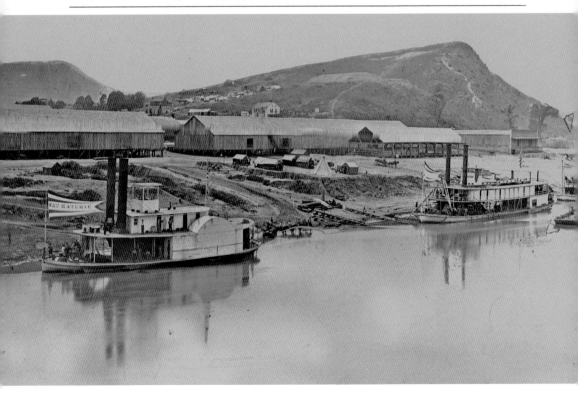

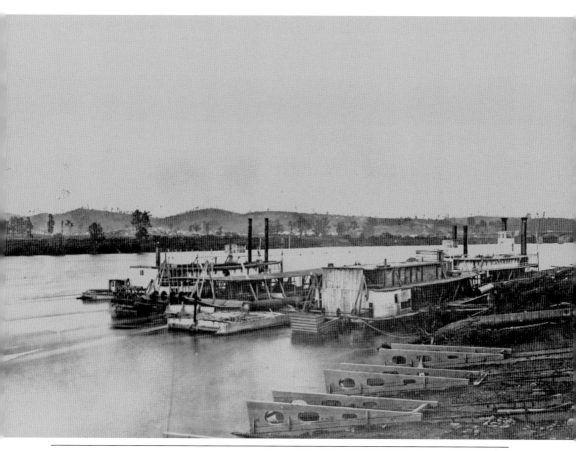

The Union shipyard at Ross's Landing was located by Cameron Hill. Where once steamboats like the *Wauhatchie* and the *Chickamauga* were hewn, recreation is now the watchword. Open spaces dominate, and entertainment such as the annual summer Riverbend Festival are typical of riverfront life today. In 2005, the city opened a long pier that has become something of a landmark, with its finely crafted aluminum beacons that reach skyward and glow at night.

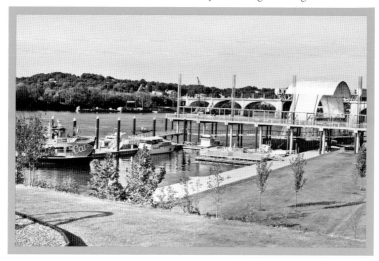

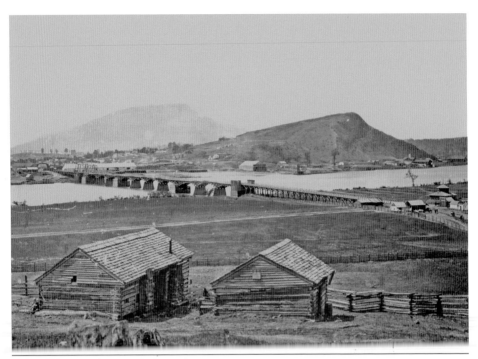

In 1864, George Barnard, the photographer assigned to the Federal forces, captured a view of the Meigs Military Bridge from the north side of the Tennessee River. Where once a wooden bridge crossed the water, the city now boasts four spans in the vicinity. Busy Frazier Avenue, with its coffee shops and eateries, is located in the middle ground. Visible in the distance is the unchanged silhouette of Lookout Mountain.

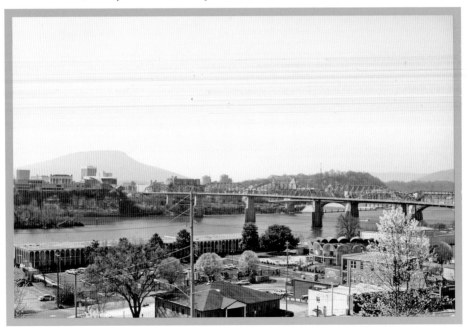

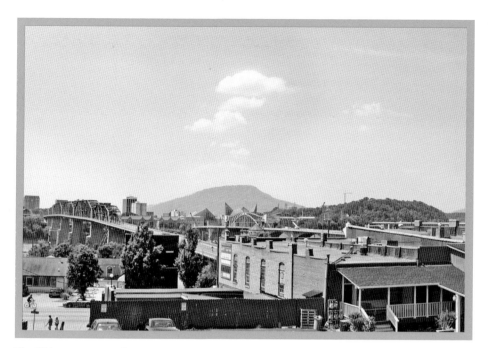

The Walnut Street Bridge now spans Coolidge Park, not a cornfield. Neither does it carry vehicular traffic, only those on foot. The dark, two-story building facing the camera stands on Frazier Avenue; once a U.S. post office, it currently dispenses sandwiches on the trendy thoroughfare. To the right in the distance is a decapitated Cameron Hill with its building cranes as it prepares to become the new corporate home of the Blue Cross–Blue Shield insurance company in 2009.

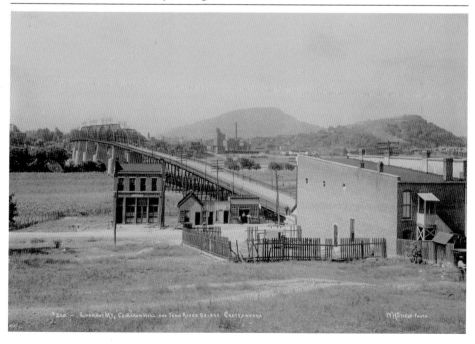

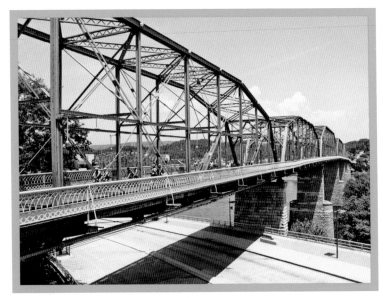

Opened to great fanfare on February 18, 1891, the Walnut Street Bridge connected downtown to the north side of the river, known then as Hill City. But in 1978, the State of Tennessee closed the bridge as unsafe. Nevertheless, preservation-minded citizens found a new use for the bridge, creating an automobile-free walkway where residents can run, stroll, or simply sit if they wish. In 1991, the 2,730-foot bridge was reopened as the world's longest pedestrian bridge.

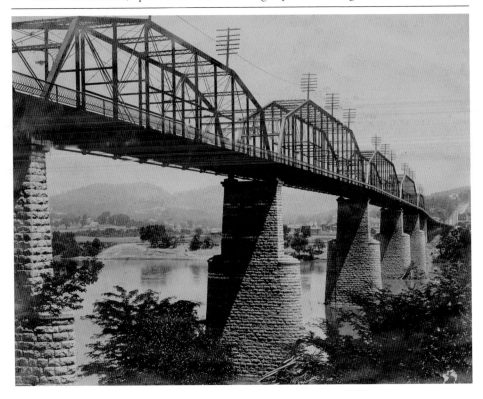

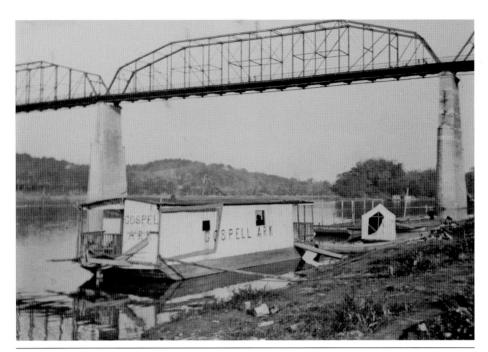

This fine-looking pleasure-craft of Plexiglas (below) is typical of boats that moor around downtown, especially on the weekends in the warmer months. With the Walnut Street Bridge towering above, this new pier for docking was completed in 2005 and can guide the visitor on foot under the Market Street Bridge to the Tennessee Aquarium. In an earlier day, the Gospel Ark (pictured above) might have anchored longer until its travelling ministry work was done.

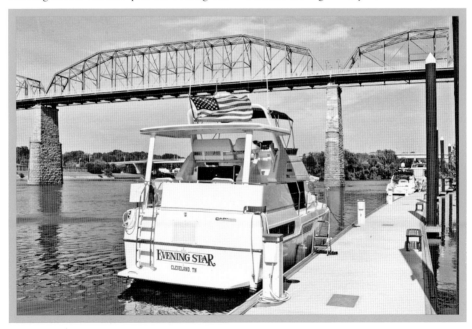

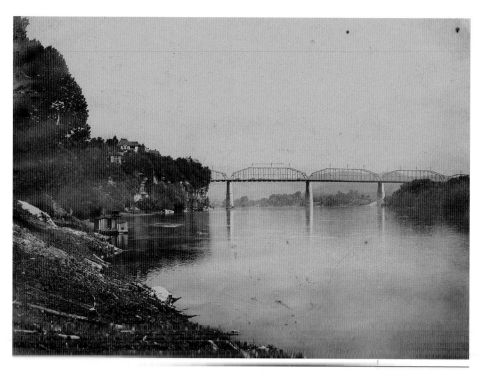

The Veterans Bridge spans Chattanooga Island in this westward view down the Tennessee River and obscures the view of the historic Walnut Street Bridge. Originally intended to replace the historic structure, the Veterans Bridge was constructed slightly upriver from the older bridge when citizen opposition to that bridge's destruction forced the always-busy Department of Transportation to change its modernization plans. Finished in 1984, the structure linked Barton Avenue to Georgia Avenue, unfortunately destroying historic homes where it crossed the river.

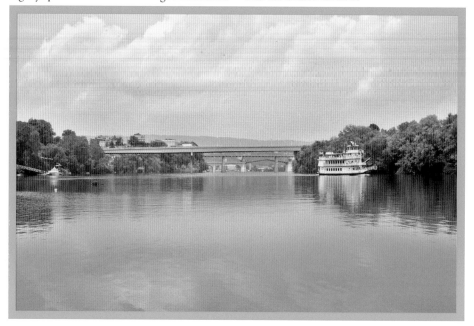

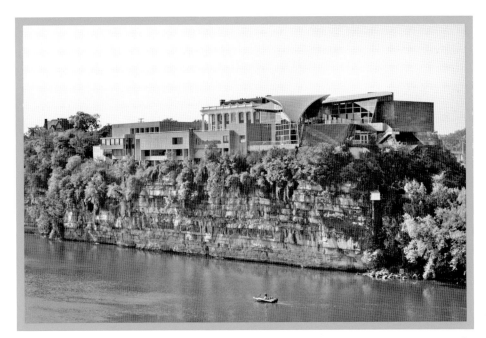

On the bluff by the Walnut Street Bridge stands the swooping, curvilinear roofline of the Hunter Museum of American Art's recent addition. To its left is the original, columned Hunter mansion, constructed in 1904. Once a prestigious address for many Victorian houses, the area is the popular home of the Bluff View Art District. Winding stairs to the right take the visitor down the bluff side past the site of a pre–Civil War blast furnace.

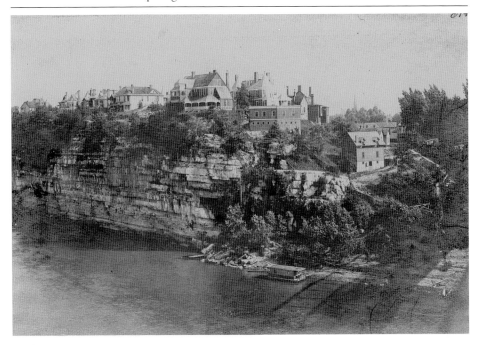

In 1854, ironmaster Robert Cravens built a blast furnace at the bluffs near the present site of the Walnut Street Bridge. It would be the first in the South to use coke fired at unusually high temperatures to separate iron ore. Unfortunately, the furnace had to be abandoned before the Union troops arrived and appropriated parts of it to construct a bridge across the river. Today its significance is marked by a wiry, cylindrical sculpture located under the Hunter Museum of American Art near the Tennessee Riverwalk.

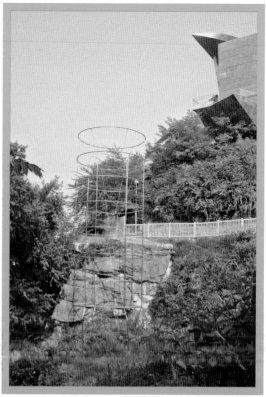

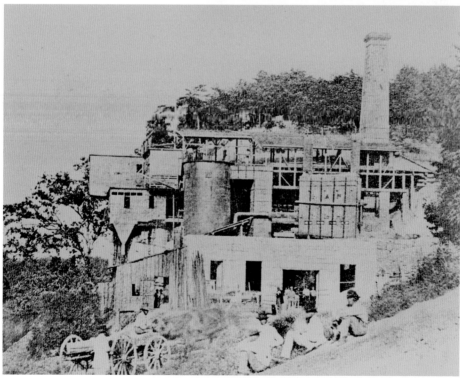

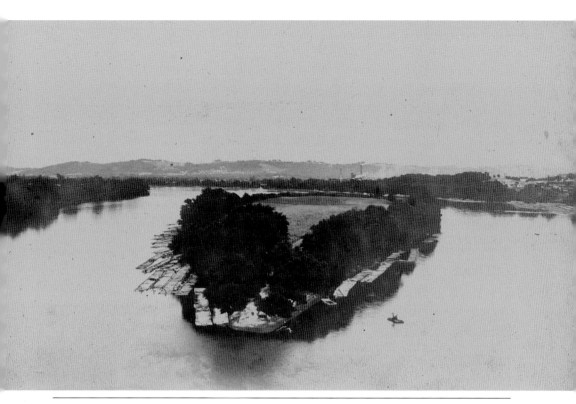

Chattanooga Island sits below the bluff that overlooks the river near Ross's Landing. Believed by archaeologists to have been occupied intermittently by Native Americans for thousands of years, the land has yielded artifacts testifying to this thesis. In Chattanooga's early days, a swing ferry was connected to part of the island. In 1954, Robert MacLellan donated the land to the local Audubon Society to serve as a wildlife sanctuary. Part of the island now sits beneath the Veterans Bridge, which opened in 1984.

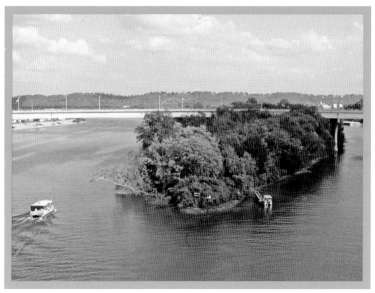

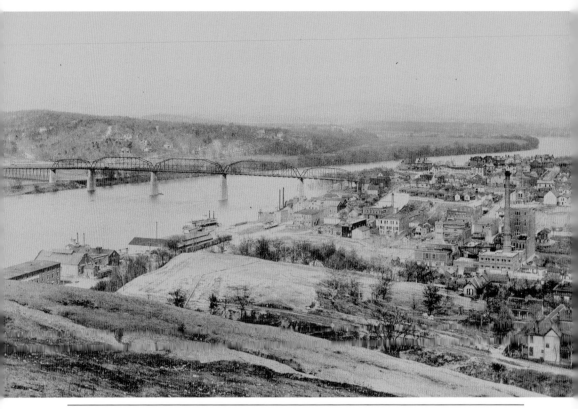

Hotels and a tour bus indicate Chattanooga's attraction as a tourist town. The large wall by the bus on Pine Street is the back of the IMAX movie theater. To the far left, some of the river is visible, while the glassy angles of the Tennessee Aquarium roof surmount the parking deck nearby. The older view (above) from the side of Cameron Hill shows Chattanooga about 1900 and includes the Walnut Street Bridge in the background.

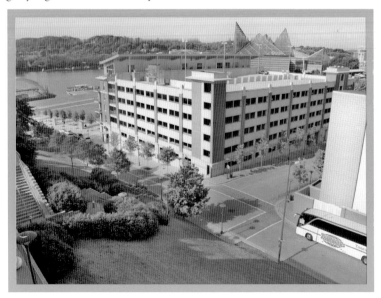

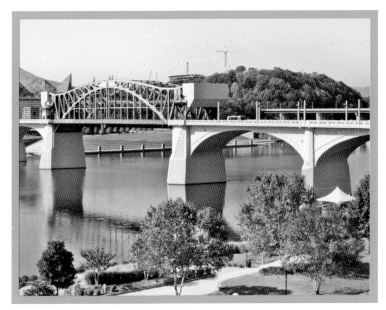

Completed in 1917, the Market Street Bridge, also known as the Chief John Ross Bridge, was the second permanent bridge to cross the Tennessee River at Chattanooga. Built of concrete with a working drawbridge, this bascule bridge has undergone extensive restoration work that was completed in August 2007. Beyond the bridge is the profile of Cameron Hill, so named for a talented painter who worked in the city before the Civil War.

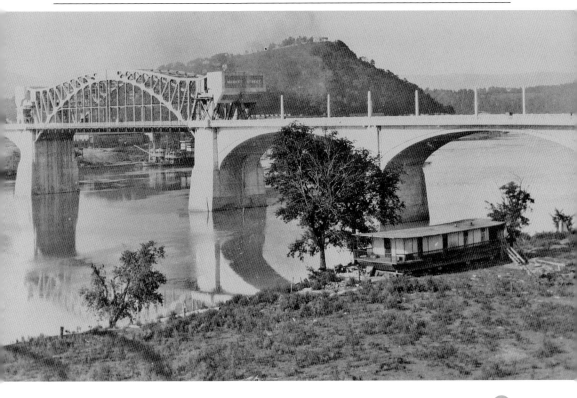

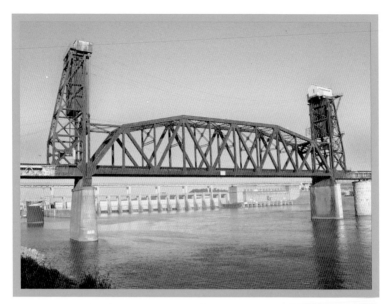

The Cincinnati Southern railroad bridge was built in 1890 north of town. Following a major fire in 1914, the trestle was reconstructed in 1920. At that time, engineers poured concrete for the bridge pillars, leaving only one of the original limestone supports standing. Now the province of the Norfolk Southern Railroad, the span remains in use and is something of a local curiosity with its houses sitting high atop the iron superstructure.

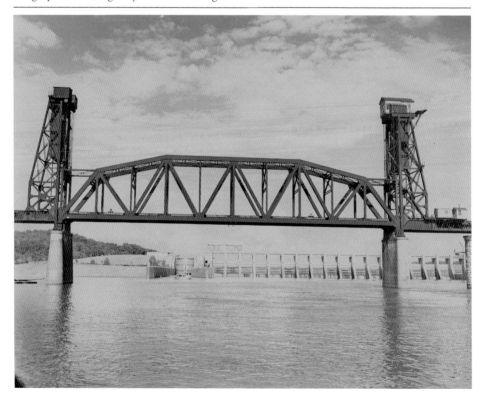

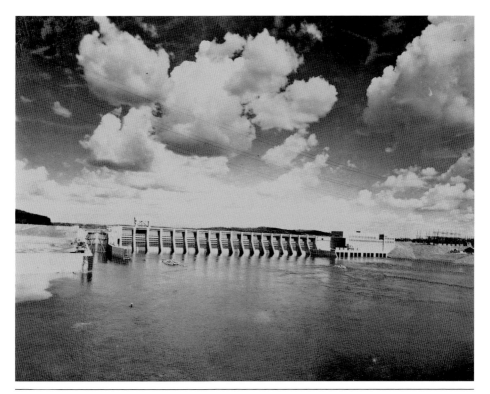

A Tennessee Valley Authority project, the Chickamauga Dam was completed in 1940 and dedicated by Pres. Franklin Delano Roosevelt on Labor Day in a ceremony that was broadcast around the country on radio. The 5,800-foot-long structure was built to control a river that flooded unpredictably. Since the construction was a federal government project, African Americans were able to secure good-paying jobs in a segregated South that usually allowed them only the most menial work. Today the Thrasher Bridge, built in 1955, carries traffic above the dam.

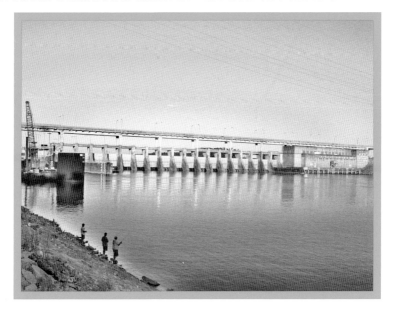

The series of dams built by the Tennessee Valley Authority resulted in a number of lakes and the submersion of thousands of acres of land and numerous family farms. As work began on the Chickamauga Dam in 1936, the Chickamauga Lake slowly came into existence. It has provided swimming, fishing, boating, and picnicking opportunities to countless residents of the valley for over 60 years.

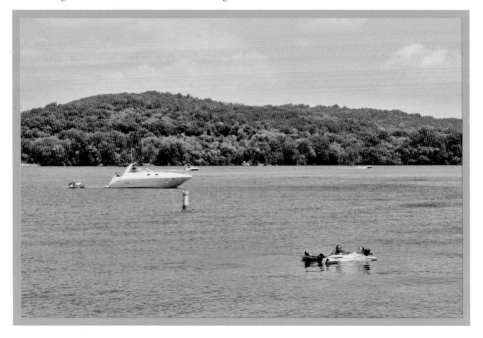

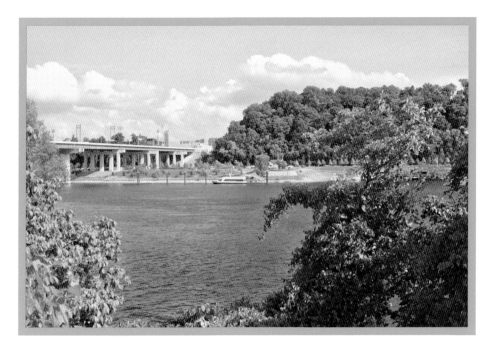

The Olgiati Bridge runs close to Cameron Hill, and the riverfront area that was the longtime location of Loomis and Hart Lumber is now a parking lot for a docking facility. This side of Cameron Hill traditionally supported industry that required access to the river. On the other hand, the top of the hill was a prestigious address for moneyed Chattanoogans 100 years ago. But by the 1960s, urban renewal efforts had cleared most of the housing for freeway construction.

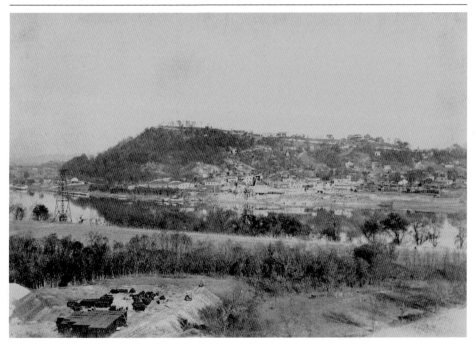

The Cummings Highway serves as a route around Lookout Mountain above Moccasin Bend. Today it serves mostly local drivers since most traffic moves along I-24 below. The roadway was named for Judge Will Cummings, an influential citizen who championed the cause of the Dixie Highway, a north-south conduit that runs through Chattanooga. The highway coincidentally promoted roadside attractions such as Rock City and Ruby Falls as the driving American public became fascinated with automobile tourism.

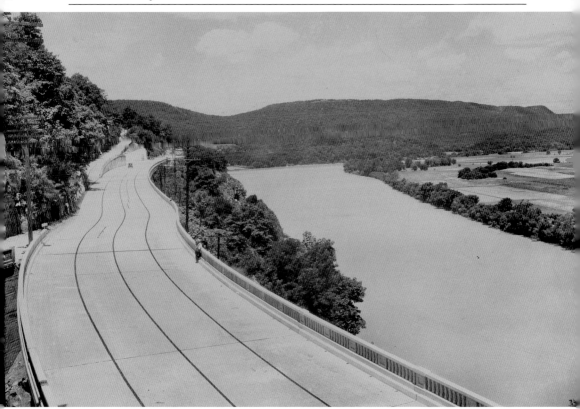

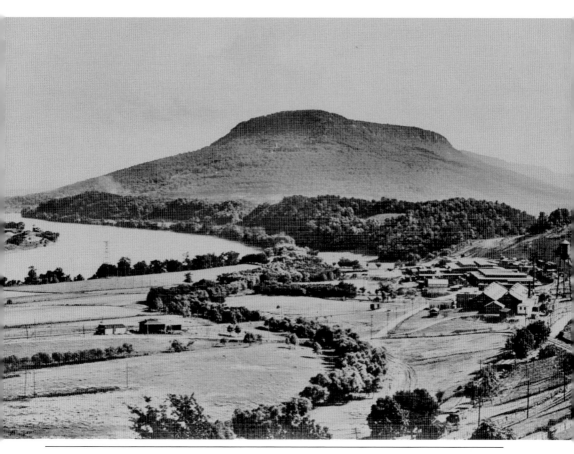

This stretch of river journeys south toward Lookout Mountain as the water passes the city of Chattanooga proper. To the right is the eastern side of Moccasin Bend. When the Cherokees were removed by the federal government from their Tennessee homeland, one part of the Trail of Tears passed along this land by the river. Farther down the waterway to the left are old industrial sites, some of which are still active today.

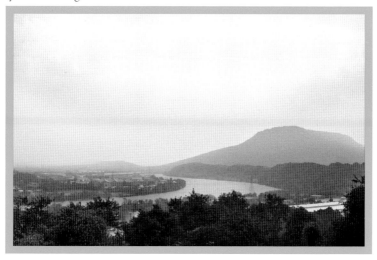

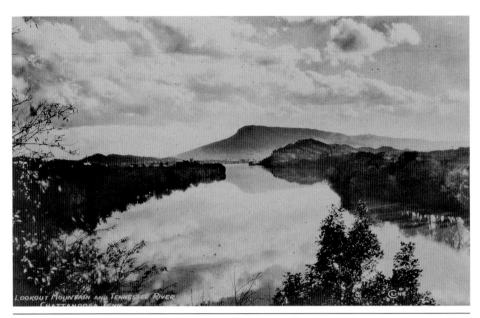

This view from Baylor School looks south along the river toward the distant outline of Lookout Mountain. To the right is Williams Island, a site with evidence of centuries of human habitation; behind it, but out of sight, rises Raccoon Mountain. In the distance is the site of Brown's Ferry, where the Union armies crossed the broad river highway as they sought to gain control of Chattanooga.

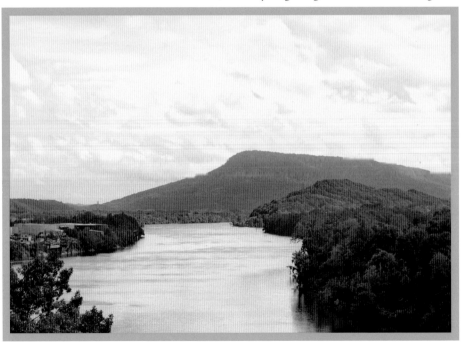

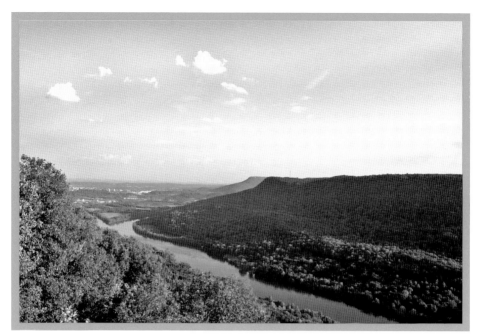

Chattanooga's mountains offer some captivating views, such as this one looking south toward the city from Signal Mountain. This particular site was useful to soldiers in the Civil War for the purpose of sending signals to other troops stationed far away, hence earning the name Signal Point. In the distance, the Tennessee River wends its way toward Moccasin Bend through the haze of summer that can be intense in the southern Appalachians.

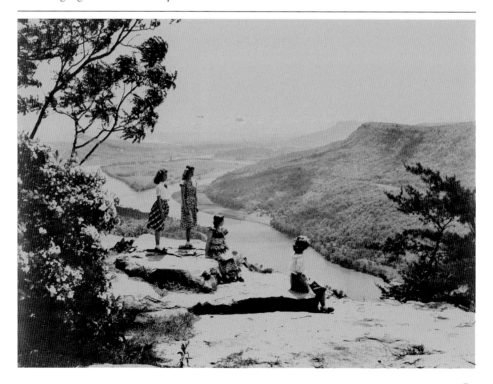

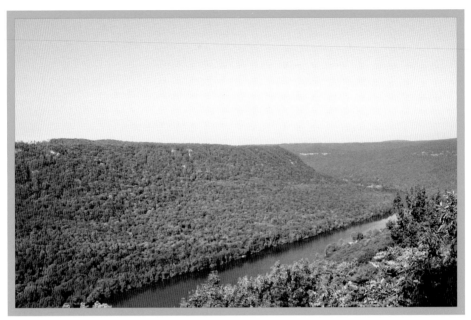

A westerly view of the river from Signal Mountain reveals a scene of beauty known as the Tennessee River Gorge. Before the Civil War, settlers coming through Tennessee had great difficulty navigating the often-turgid river, as well as the tricky undercurrents, in locales called the "Pot," the "Pan," the "Skillet," and the "Suck." A land trust has been active for years in securing land around the river in order to preserve its beauty for future generations.

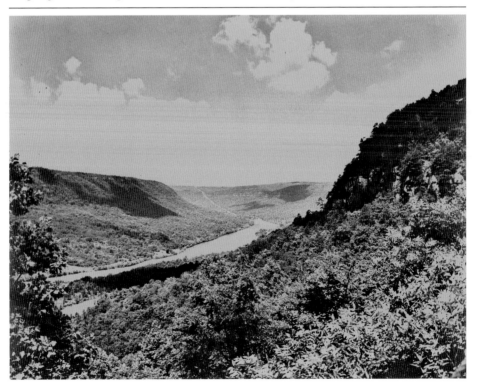

HEART OF THE CITY

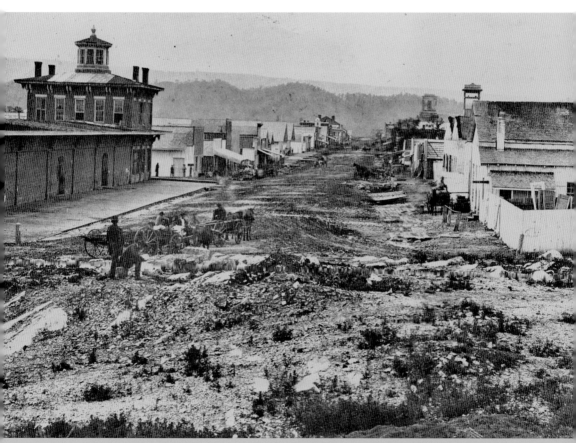

When the Union army entered Chattanooga in 1863, it found less of a city and more a rough assemblage of buildings. This view looking north on Market Street, the city's main thoroughfare, shows the Western and Atlantic Depot, the terminus of the railroad from Atlanta, on the left at Martin Luther King Boulevard (formerly Ninth Street). Wood-frame stores line the street that ends near Ross's Landing on the Tennessee River, with the hills of North Chattanooga in the distance.

Reuben Harrison Hunt was the architect of one of Chattanooga's finest office buildings, the James Building. Opened in 1907, the 12-story Wainwright-style structure stands at the corner of Broad and Eighth Streets. Underwritten by Charles James, a real estate magnate instrumental in developing Lookout and Signal Mountains, the building has housed a number of important local financial enterprises for decades.

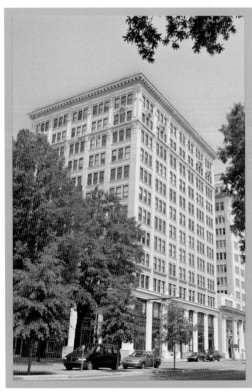

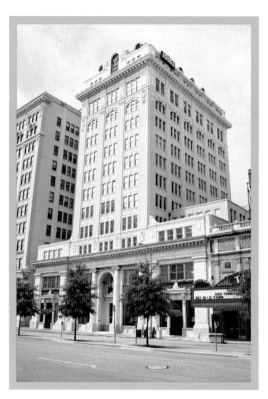

One of Chattanooga's more elegant structures is certainly the MacLellan Building. Another R. H. Hunt work, the building was finished in 1924 and bears the name of Thomas MacLellan, who headed the Provident Life and Accident Insurance Company, one of Chattanooga's great success stories. Today the company is part of the Unum Provident Insurance Company, and the building, home to other firms, is listed on the National Register of Historic Places.

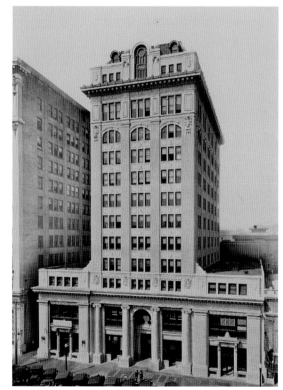

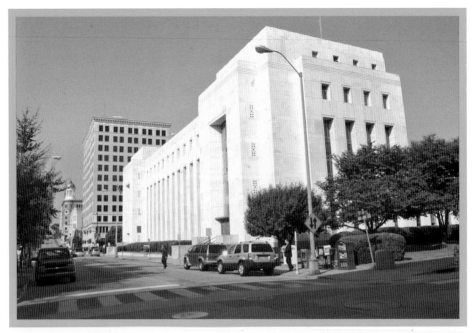

Chattanooga's outstanding example of art deco architecture is surely the Joel W. Solomon Federal Building. Built in the 1930s and designed by R. H. Hunt, this Georgia Avenue edifice is made of Georgia marble and features long vertical windows faced with aluminum grilles. One courtroom contains a 17-foot oil painting depicting Chattanooga's colorful history. Probably the city's most famous trial took place in 1964 when Jimmy Hoffa, the controversial head of the Teamsters Union, was convicted of jury tampering.

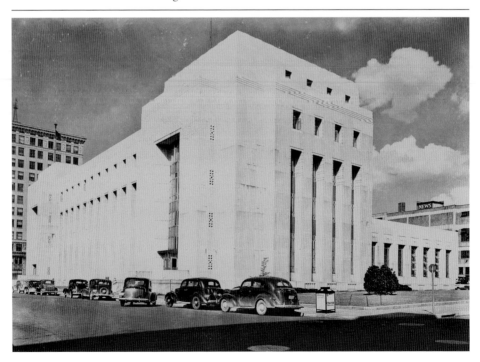

HEART OF THE CITY

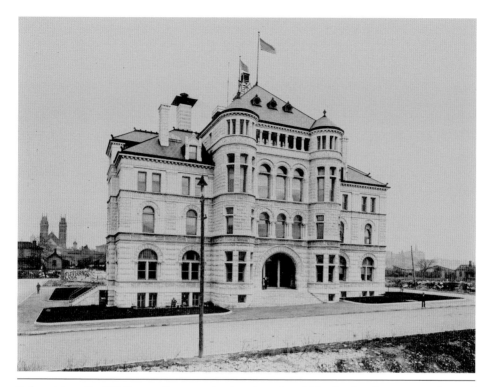

Referred to as the Old Custom House, or simply the Custom House, this 1893 structure towered over anything nearby when it was built. Its address on Eleventh Street was somewhat out of the central business district at the time, but its imposing Richardsonian Romanesque form of stone left no doubt about its importance or its permanence. Designated as the federal post office until the Solomon Federal Building assumed that duty, it now houses a variety of services.

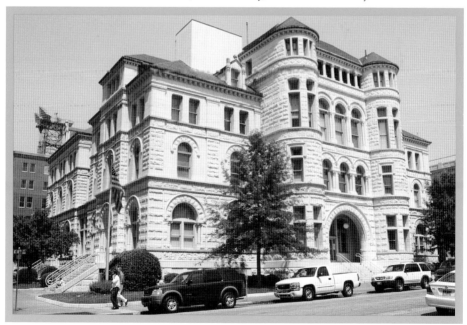

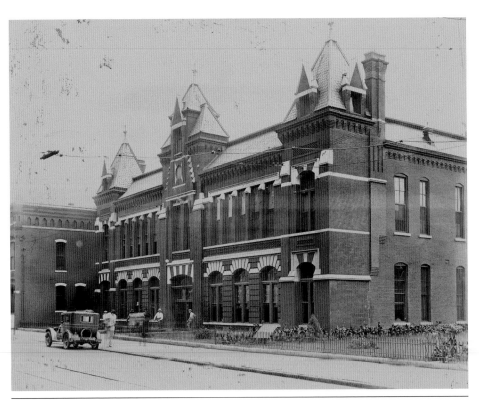

Starting in the 1850s, Chattanooga thrived as a railroad town; by the 1880s, the need for a new train station brought about the construction of the Union Depot. Situated across from the Read House hotel, the Victorian railroad terminal included impressive light and dark brickwork on its facade. Standing approximately where the glass tower and the Krystal Company headquarters are today, the structure was razed in 1972; by then, passenger rail service was almost a memory.

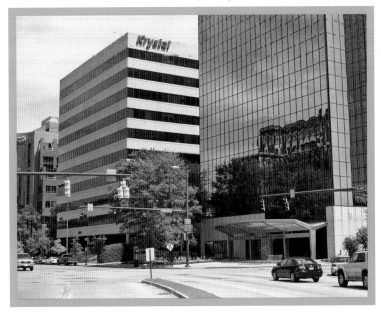

Where once steam engines blew their shrill whistles, now search engines do much of the work in the concrete Chattanooga–Hamilton County Bicentennial Library. The library sits where rail lines were once partially covered by a huge stone- and-brick railcar shed. Finished in 1858, the sturdy structure stretched out over 300 feet and spanned four tracks. Besides its usual business during the Civil War, the shed also served as a refuge for wounded soldiers from both sides of the conflict.

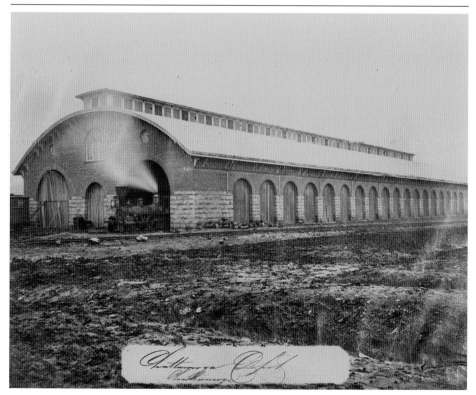

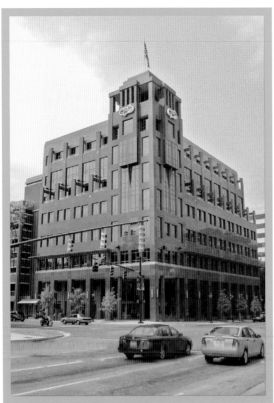

The building that houses the Electric Power Board was constructed in 2005 and sits where Chattanooga's first passenger and freight depot once was at Market Street and Martin Luther King Boulevard (formerly Ninth Street). The old terminal was a simple affair with a cupola atop its two stories. The depot served the Western and Atlantic Railroad, a line that had been chartered in 1836 by the State of Georgia to be built north from Atlanta to its northern terminus at Chattanooga, which it gained in 1850.

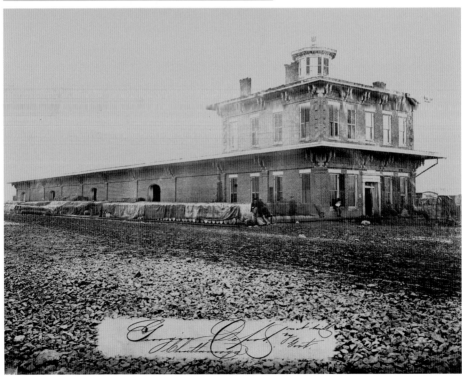

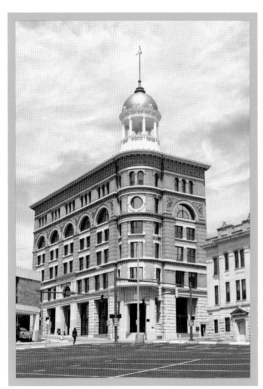

A picturesque six-story structure, the Dome Building—or Times Building as it was once commonly known—stands at Georgia and Sixth Avenues. With its Italian Renaissance–style architecture and brilliant dome, it occupies a distinct place in Chattanooga's urban landscape. Constructed in 1892, it marked the success of Adolph S. Ochs, the founder of the *Chattanooga Times*, an influential newspaper for a century in the South. Och's legendary business prowess eventually enabled him to purchase the *New York Times*.

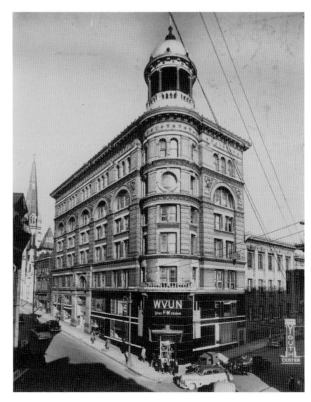

For a century, Loveman's
department store represented
the finest tradition in retail
shopping that Chattanooga had to
offer. Now devoted primarily to
condominium living, the Market
Street institution with the finely
appointed interior opened in the
mid-1880s, only to burn in 1891.
The store was already so successful
that it was rebuilt within a year
and continued unabated until its
doors closed in 1993, overwhelmed
by the malls and catalogs of the
modern shopping world.

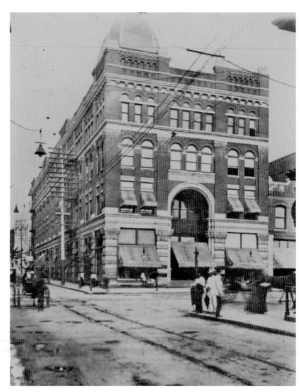

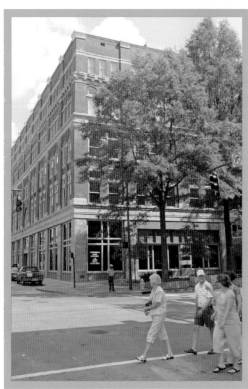

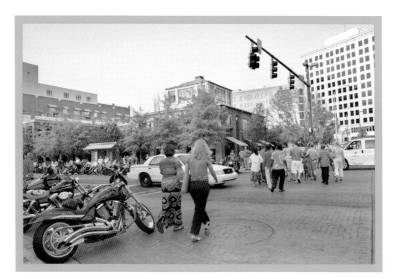

A Friday night concert at Miller Park at the corner of Martin Luther King Boulevard and Market Street is a popular summer ritual in Chattanooga. Free music and down-home food attract a varied audience, which usually includes a block's worth of proud motorcyclists. With the covered Waterhouse Pavilion (center of photograph) near the stage and plenty of room to wander around, the park, named for attorney Burkett Miller, is a pleasant improvement over its predecessors, which included the concrete Allright Auto parking garage.

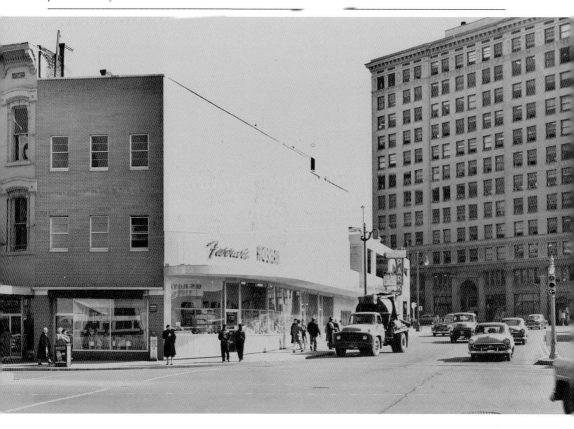

This location has always supported a hotel, beginning with the Crutchfield House. Built by Thomas Crutchfield in 1847, it sat across from the Nashville and Chattanooga railroad terminal. In 1861, a speech by Confederate president Jefferson Davis here was the scene of angry words among local residents. When the building burned in 1867, a new structure, the Read House, was erected. That Read House was replaced in 1926 by the present one, which features a handsome walnut lobby.

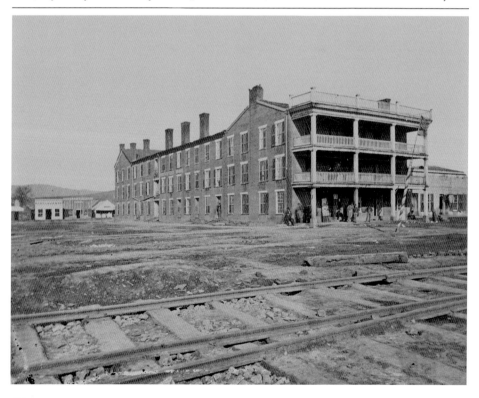

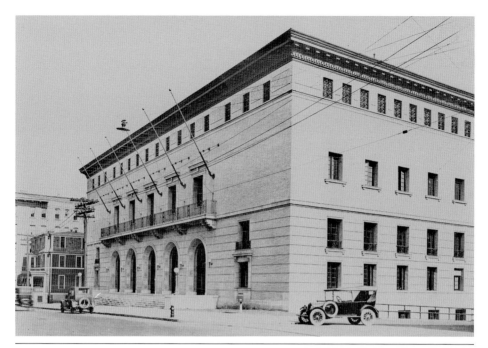

Following World War I, Chattanooga appointed R. H. Hunt to design a new auditorium for the city since the previous one had burned in 1916. Dedicated to those who fought in the European battles, the Soldiers and Sailors Memorial Auditorium opened on McCallie Avenue as the city's largest public venue for concerts. A full house of music lovers in 2007 witnessed the performance of the stately, renovated, concert pipe organ, which had lain in disrepair for decades.

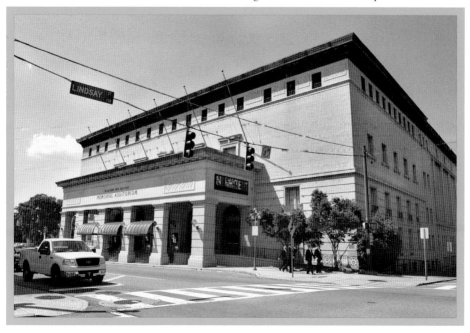

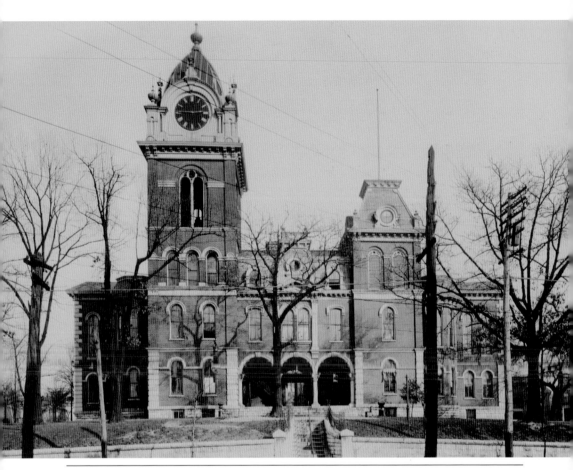

When Hamilton County was formed in 1819, Chattanooga was only a river landing. After the Civil War, the city was made the county seat and, by 1870, had a county courthouse built with a bell tower 120 feet high. A lightning strike in 1910 destroyed the building; the new architect, R. H. Hunt, changed the entrance to face the south. Today the western side of this finely crafted courthouse shows its Tennessee marble facade to great advantage.

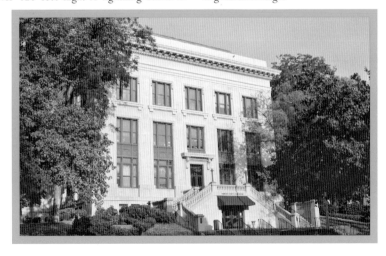

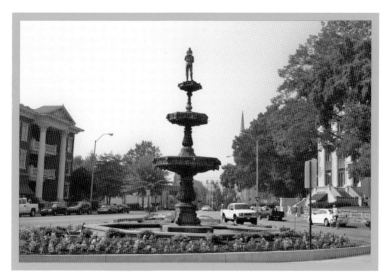

This 27-foot-high fountain on Georgia Avenue is a monument to two firemen who answered an alarm one day in 1887 and never returned. The fire occurred down the hill from this site on Market Street at the Bee Hive Store, where an unexpected explosion took their lives. Dedicated in 1888, the three-tiered memorial runs continuously and is especially captivating when freezing temperatures turn the water into an icy cascade.

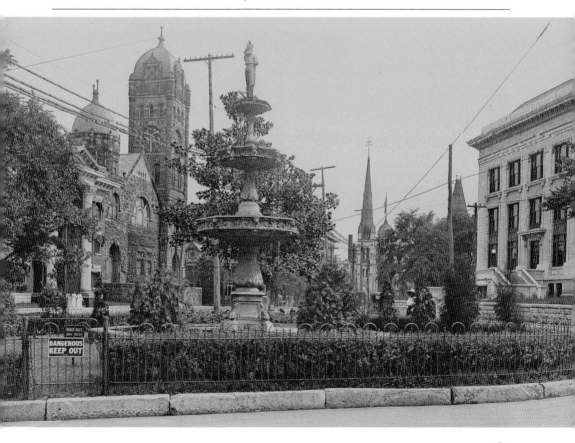

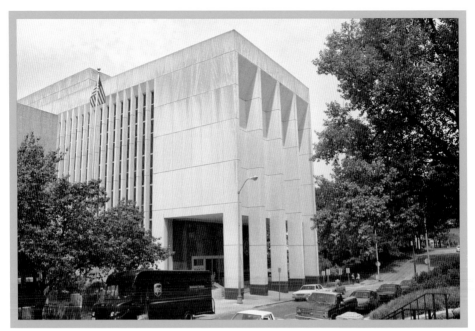

This solid white block of a building at the corner of Walnut and Sixth Streets is the Hamilton County Justice Building. Its somber edifice was preceded at this site by a house of entertainment, the Bijou Theater, which showed movies as its main fare, though it occasionally featured a variety of traveling acts. Opened a century ago, it succumbed to fire and was torn down in 1949, replaced about 30 years later by the current county structure.

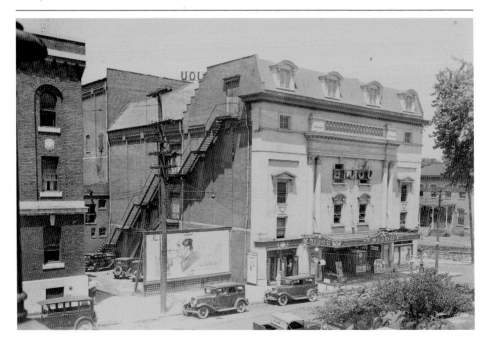

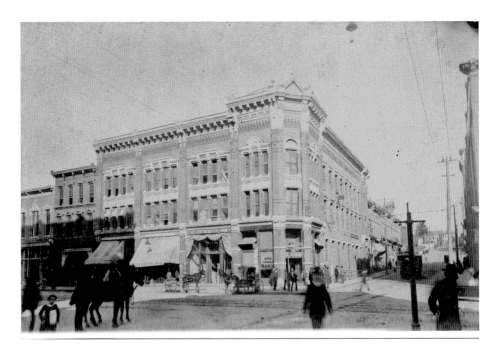

One of Chattanooga's oldest and most distinctive commercial structures is the Central Block Building on the corner of Market and Seventh Streets. Once the home of Live and Let Live Drug Store, the 1883 building now serves as the home of the United Way Agency. One of the latest victories for preservationists in Chattanooga, the decorative brickwork has returned to prominence following the recent restoration and cleaning of the facade.

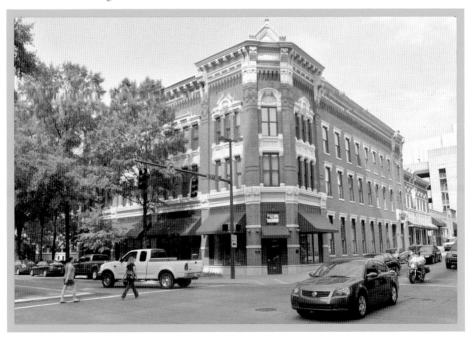

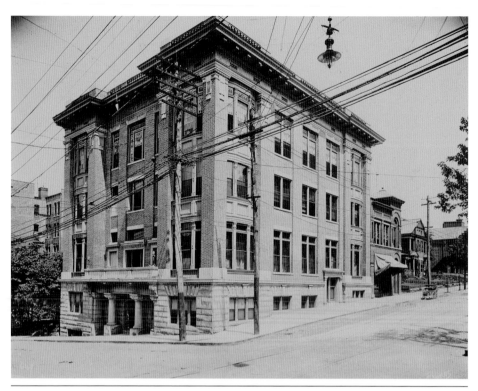

The area around the Hamilton County Courthouse includes a number of historic structures such as this one that faces Seventh Street. The early 20th century saw a great deal of construction in Chattanooga, and the Elks Building, which was finished in 1907, was part of that trend. Fraternal organizations were in their heyday and could bankroll whole buildings, as well as good architects like Charles Bearden, who also designed the nearby Hardwick-Hogshead Apartments.

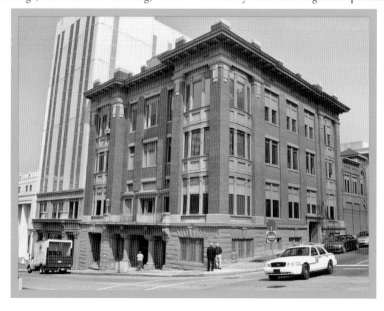

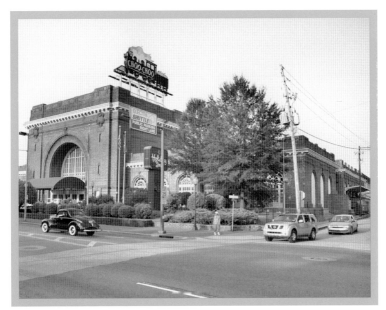

The Southern Railway Terminal Station came to life in 1909, replacing a handsome five-story hotel known as the Stanton House that had failed some years earlier. The edifice boasts an impressive, 85-foot-tall, arched brick entrance that was the largest ever built when the grand opening took place. The work of New York architect Don Barber, the station was much admired in architectural circles and today is a convention and hotel facility named the Chattanooga Choo-Choo.

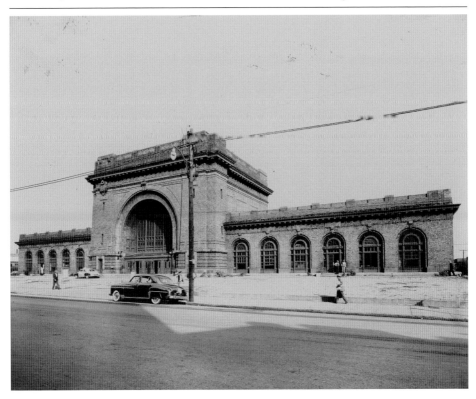

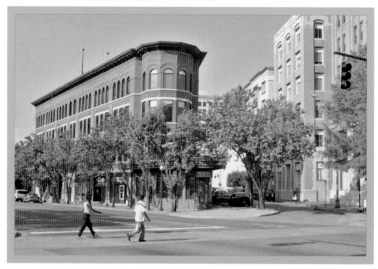

Chattanooga's street layout created some intersections with commercial structures that have a triangular or "flat iron" shape. Constructed in 1893, when railroading was at its height, the Southern Express Company building stands where Market Street and Georgia Avenue meet at a point. It served as a hotel for many years and today contains several businesses, one of which is the Pickle Barrel, a popular restaurant that offers rooftop seating.

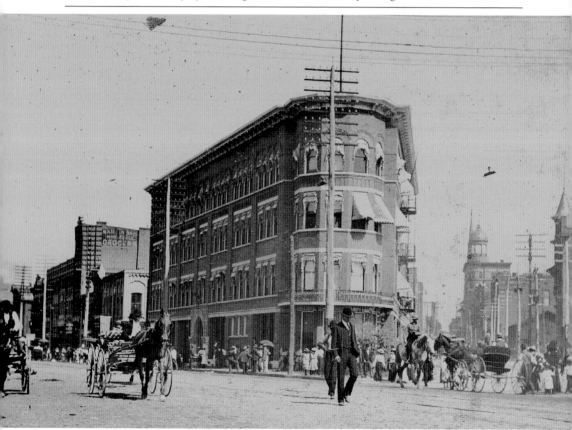

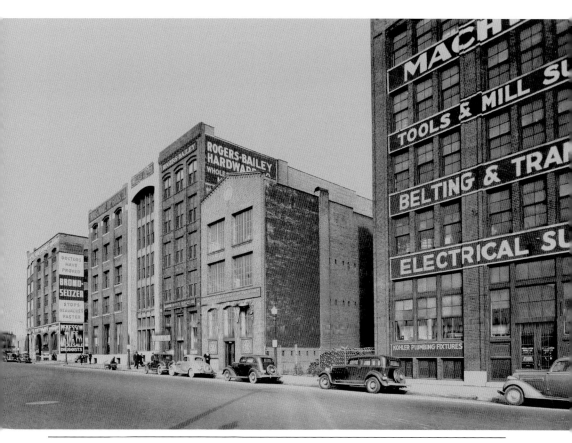

This group of contiguous commercial buildings bears the moniker Warehouse Row and offers a number of specialty shops of quality goods to those seeking values in downtown Chattanooga. Originally built in the early 1900s to be warehouses for all sorts of freight, they face Chattanooga's main roadway at that time, Market Street. Located within two blocks of the rail yards to the west, their rear entrances easily accessed lines from the other direction as well.

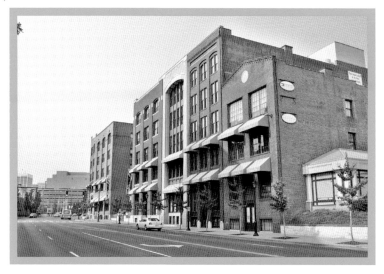

For over 30 years, this building served as a hospital for African American citizens in the city. Located on East Eighth Street in a neighborhood that has increasingly become part of the University of Tennessee at Chattanooga, the Walden Hospital was begun in 1918 by Dr. Emma R. Wheeler, a Meharry Medical School graduate. The facility served African American citizens and allowed black doctors to practice medicine and treat patients at a time when racial discrimination severely limited their opportunities.

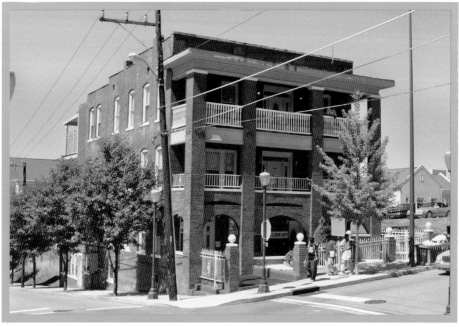

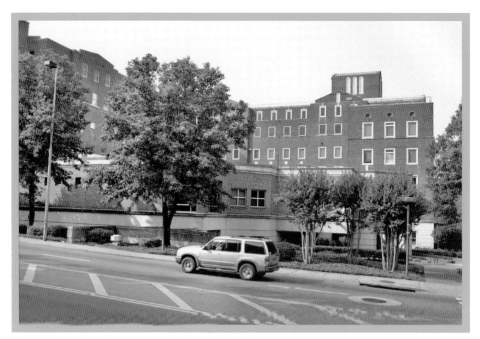

On a visit to Chattanooga in 1889, Baron Emile Erlanger, who had financial interests in local railroading, offered during a dinner toast to donate $5,000 toward the building of the city's first hospital. Named for his lovely wife, a native of Louisiana, the hospital accepted its first patient in 1899. After a century, Erlanger Medical Center has grown enormously; this modern photograph depicts the hospital's center portion, which contains sections of the original structure.

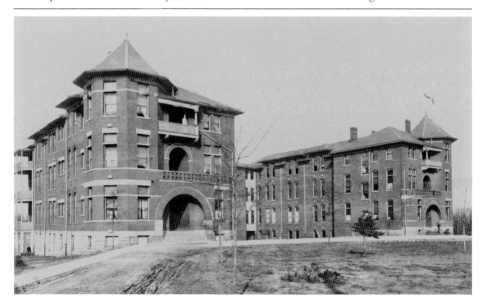

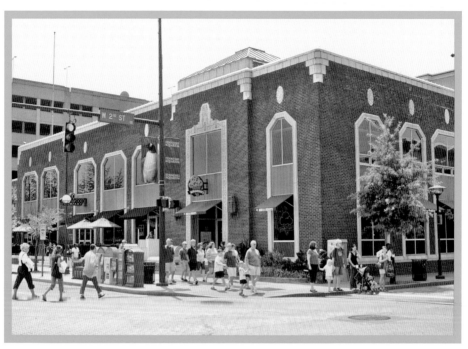

In 1899, two Chattanooga men, Benjamin Thomas and Joseph Whitehead, completed an agreement with Asa Candler of Atlanta to have the exclusive right to bottle his new drink called Coca-Cola and distribute the beverage across most of the United States. For years, large glass windows in this building at Broad and Second Streets allowed pedestrians to watch the fizzy stuff being bottled. Today the building's restaurants serve fine food to hungry visitors—with Coke, of course.

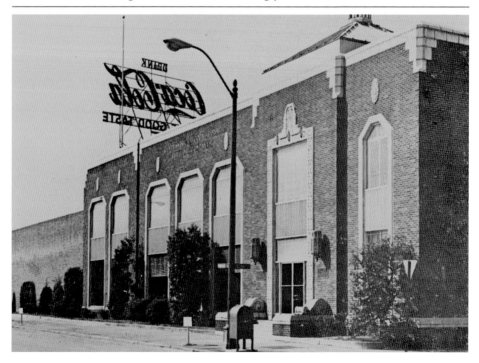

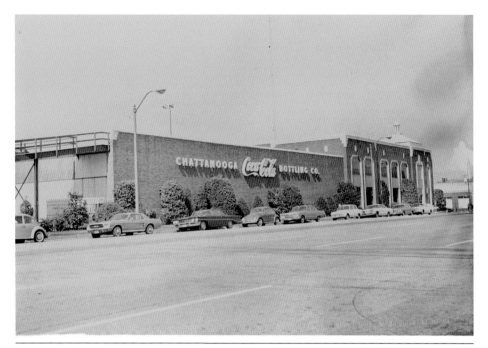

The busy Coca-Cola bottling plant originally stretched a block. This view (below) from Broad and Third Streets looking north depicts the Bijou Theater and the parking deck that replaced the southern end of the plant, the portion denoted by the lettering shown above. The glass roof of the Tennessee Aquarium shines in the distance. Upon opening in the 1990s, the Bijou was Chattanooga's first downtown movie theater in two decades. Before Coca-Cola bottling was located here in the 1920s, this entire block was occupied by the six-story Chattanooga Brewery for years before its business collapsed during Prohibition.

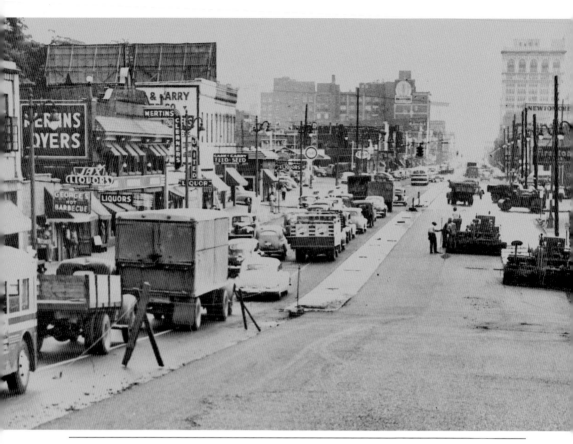

Street pavers on Market Street in 1948 saw a scene markedly different from today. Many small businesses have come and gone. The impact of the Tennessee Aquarium, immediately to the right but out of view, has spawned several new restaurants, and the pedestrians are for the most part tourists rather than merchants. The brick trolley carbarns in the distance down Market Street still remain, but instead of offering rides, modern vendors court visitors with food and music.

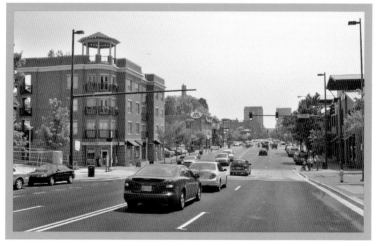

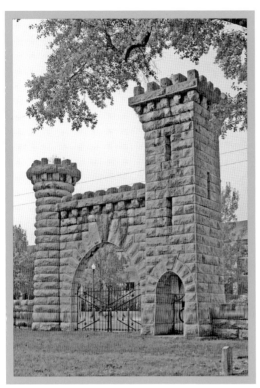

This well-hewn stone structure was dedicated in 1902 and marks the entrance to the Confederate Cemetery, which was created for the Southern dead after the Civil War. This 1916 photograph (below) pictures the gates' architect, L. T. Dickinson, standing at his wife's grave. Bordering the campus of the University of Tennessee at Chattanooga and adjacent to the Chattanooga City Cemetery, the burial ground holds more than 1,000 soldiers and their spouses.

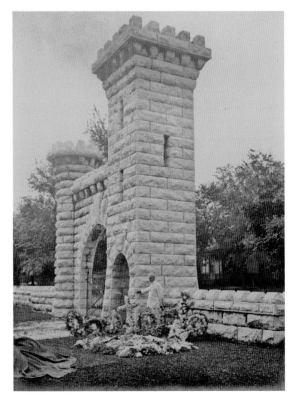

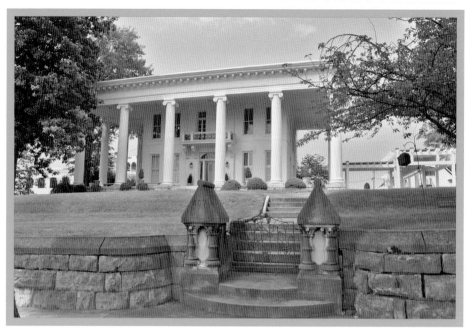

The Brabson House stands on a hill on East Fifth Street where Congressman Reece Brabson had it sited just years before the Civil War. The domicile served as a hospital for both Southern and Northern soldiers during the conflict; it suffered a fire many years later. Loveman's department store owner D. B. Loveman purchased the home in 1902 and added the columns in the 1930s, giving the structure the classical-style visage it displays today.

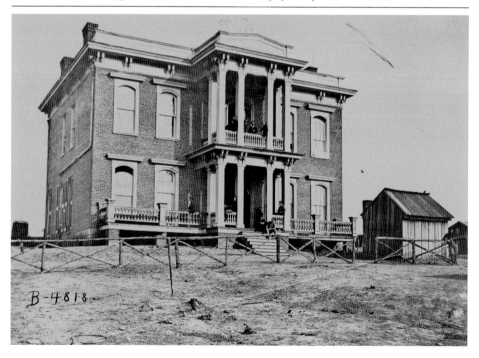

B-4818

3

FAITH, HOME, AND EDUCATION

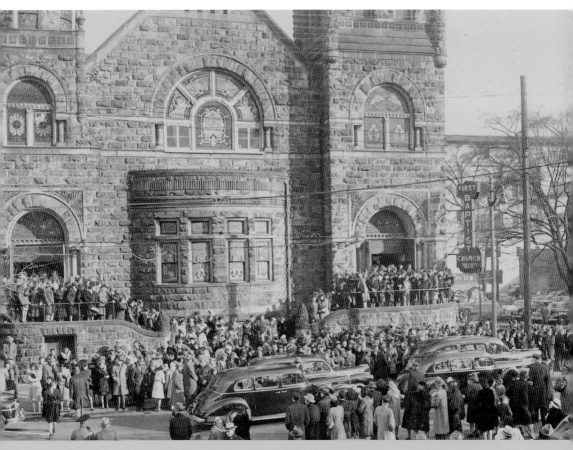

Chattanooga claims ties to two opera stars, Roland Hayes and Grace Moore. Pictured here, a throng of mourners gathers in front of the First Baptist Church at Moore's funeral in February 1947. The impressive, cut-stone, Romanesque building stood for 80 years across from the courthouse on Georgia Avenue before changing times convinced the congregation to move to a new locale near Cameron Hill in the 1960s. Built in 1887 by a young Chattanooga architect named R. H. Hunt, the house of worship featured a monumental bell tower that measured 140 feet and held a bell of bronze weighing a ton.

One slender, pointed tower made of local limestone is all that remains of the First Methodist Episcopal Church. It opened in 1885, a few years before its neighbor, the First Baptist Church, during an economic boom time in Chattanooga. The church eventually merged with the Centenary Methodist Church in the 1960s; the church's new owner elected to keep the stone tower intact on the corner of Georgia and McCallie Avenues, where it stands today.

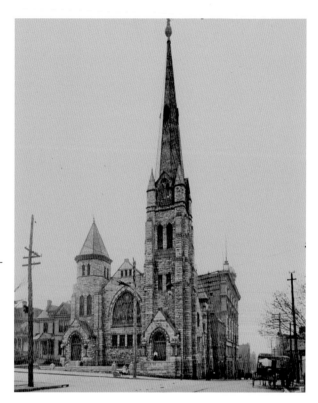

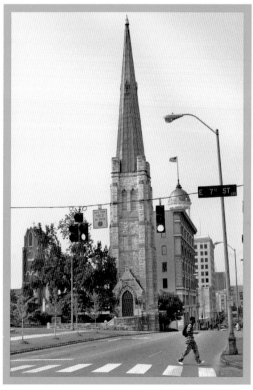

FAITH, HOME, AND EDUCATION

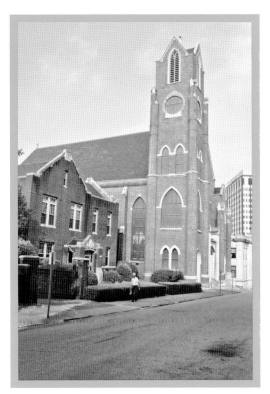

Though the South is predominantly Protestant, the Roman Catholic faith has maintained a vibrant presence in the region, as indicated by SS. Peter and Paul's Church. A block south of the First Methodist Episcopal Church, this congregation was established by the time of the Civil War and was built in what was a small Irish section of town. Originally constructed with two towers, the church decided to replace these two with one tower during renovation work in the 1930s.

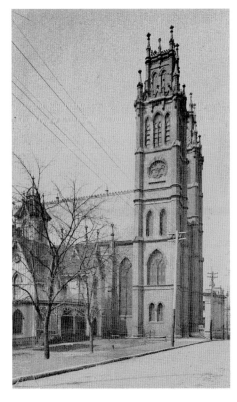

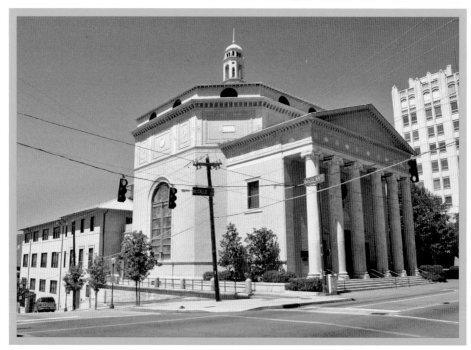

One of Chattanooga's outstanding pieces of architecture, the First Presbyterian Church on McCallie Avenue has its roots in early Chattanooga history. One of the congregation's earlier sites was on Market and Seventh Streets, where a worship service was literally interrupted by Federal cannon shells. The current columned structure was designed by the famous national firm of McKim, Mead, and White and is listed on the National Register of Historic Places.

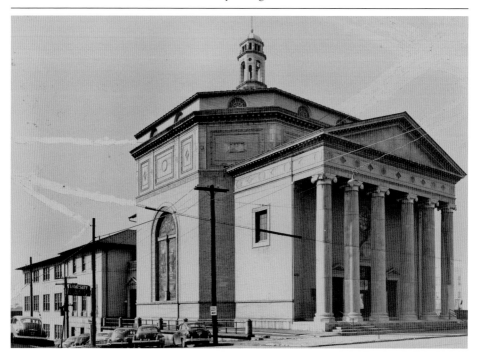

FAITH, HOME, AND EDUCATION

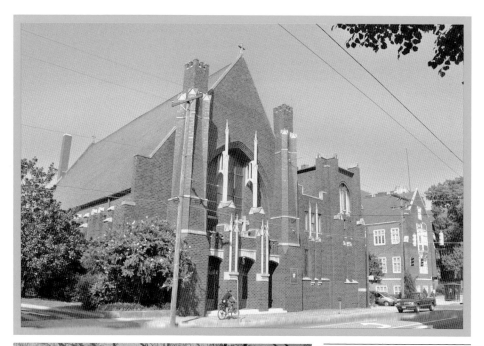

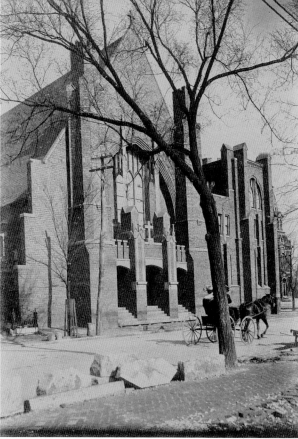

Across from the First Presbyterian Church on busy McCallie Avenue is the Christ Episcopal Church. Organized at the beginning of the 20th century, the congregation laid the cornerstone of the building in 1906, and the dark brown brick church opened its doors for worship services in 1908. Consecrated in 1944, Christ Episcopal Church has always been involved in the university community that surrounds it on three sides.

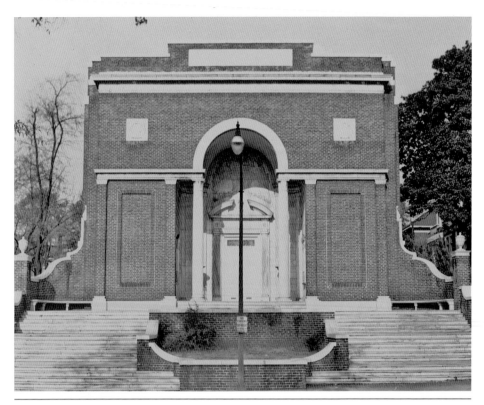

Ochs Memorial Temple on McCallie Avenue stands as a tribute to the memory of Julius and Bertha Ochs, the parents of Adolph Ochs. Adolph Ochs was the owner of the *Chattanooga Times* and eventually became the publisher of the *New York Times*. Although the Mizpah congregation had a satisfactory temple closer to town, the offer by the wealthy Ochs to build a new home for the Reform group was accepted, and the handsome synagogue opened in 1928.

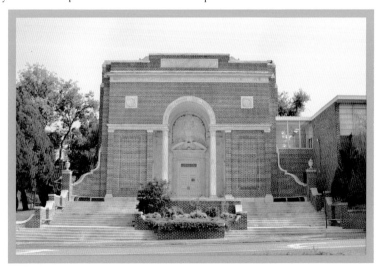

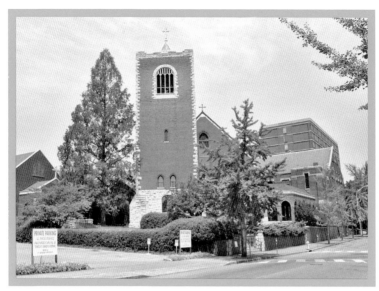

Ensconced at the intersection of Pine and Seventh Streets is St. Paul's Episcopal Church, serving a congregation that predates the Civil War. Built in 1885, the church was designed by a New York architect who modeled his design after a structure on the Isle of Man. The tower, with its distinctive stone quoins and louvered openings, stands over a church with a darkly beautiful brick interior complete with wooden crosses spanning the rafters and a stunning altar of light Italian marble.

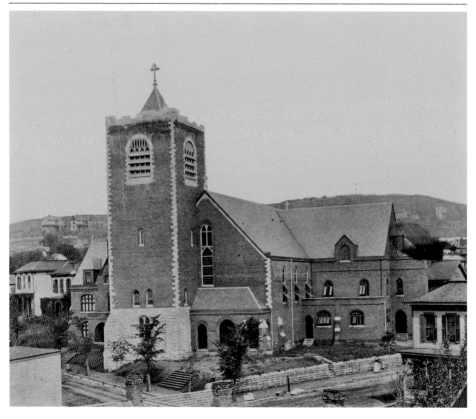

Across the street from St. Paul's Episcopal Church at Pine and Seventh Streets is architect R. H. Hunt's oldest extant building, a Romanesque-style church made of sandstone. A square belfry with an attached rounded tower provides a singular architectural presence. Built in 1891, the church served the expanding Presbyterian community, which has always been strongly represented in the Chattanooga area with its mountain ancestry of Scotch-Irish immigrants.

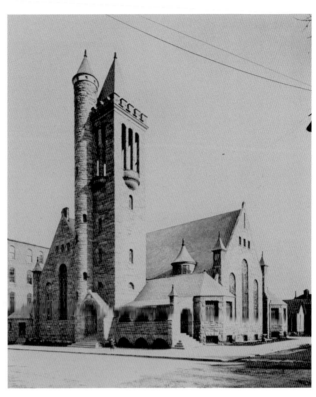

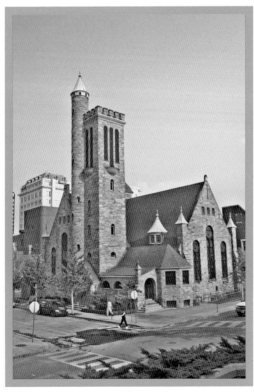

FAITH, HOME, AND EDUCATION

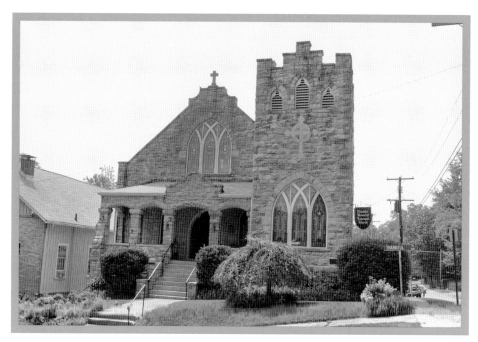

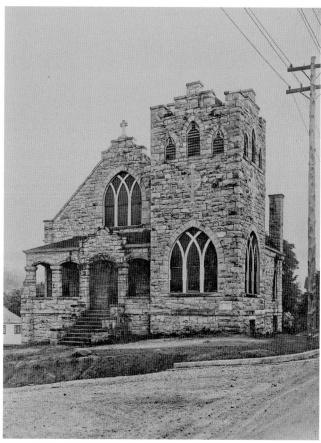

Situated at the foot of Lookout Mountain, St. Elmo was Chattanooga's first suburb of real substance. Accessible to the top of the mountain via incline rail, the community flourished beginning in the late 1890s and is the scene of a great deal of historic rehabilitation today. Built in 1907, Thankful Memorial Episcopal Church is one of many small neighborhood churches and was named for Thankful Whiteside Johnson, wife of Col. A. M. Johnson, the propulsive force behind St. Elmo's development.

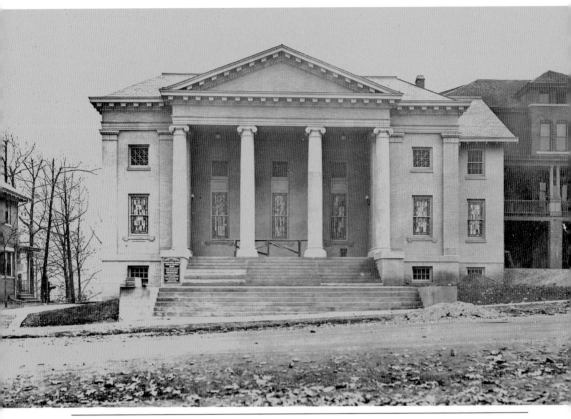

The north side of the Tennessee River across from downtown was essentially farmland until the opening of the Walnut Street Bridge allowed residential development in the 1890s. Many churches that were built in the area, such as the Northside Presbyterian Church, came into existence in the early 1900s. This classically styled church was designed by Chattanooga's prolific architect R. H. Hunt and is situated near the top of a high hill on Mississippi Avenue.

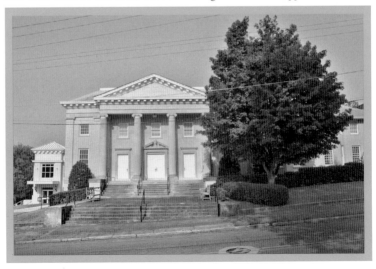

FAITH, HOME, AND EDUCATION

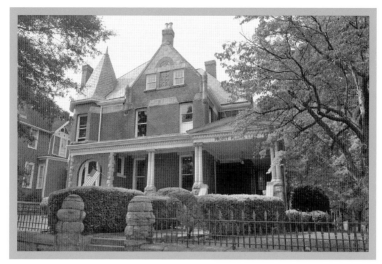

Vine and Oak Streets run parallel to McCallie Avenue and are fairly integrated into the university community. Both streets boast beautiful houses built in the early 1900s—many of which have been renovated—and large oak trees that lend an atmosphere of grace to the neighborhood known as Fort Wood. This Vine Street house, built in 1891, was the home of Maj. Joseph and Alice Warner, active citizens in the Chattanooga of their day.

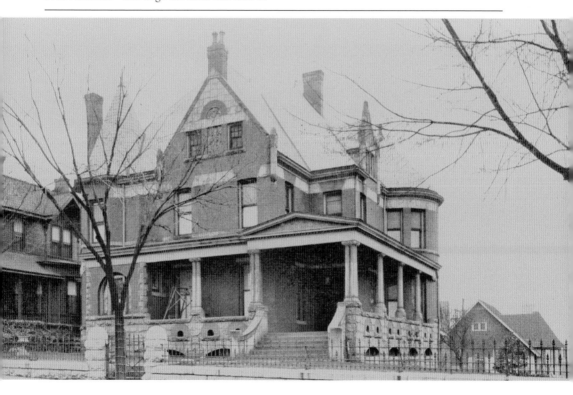

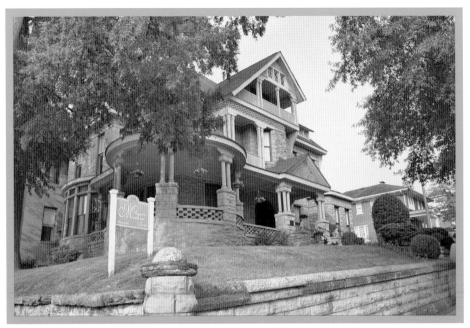

Another of Chattanooga's outstanding architects, Samuel Patton, put his stamp on this handsome house of stone in 1889. Built on a corner lot on Vine Street for Mayor Edward Watkins, the dwelling features a cut-stone exterior, numerous small columns, and a distinctive rounded porch that overlooks the city as it gazes toward Lookout Mountain in the west. Today the home serves as a bed-and-breakfast appropriately called the Mayor's Mansion Inn.

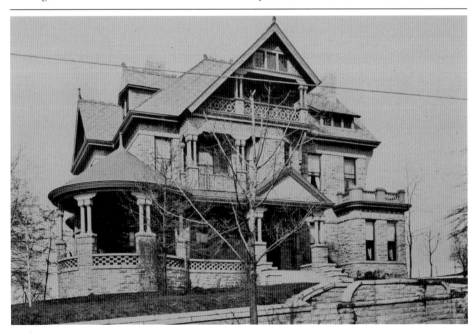

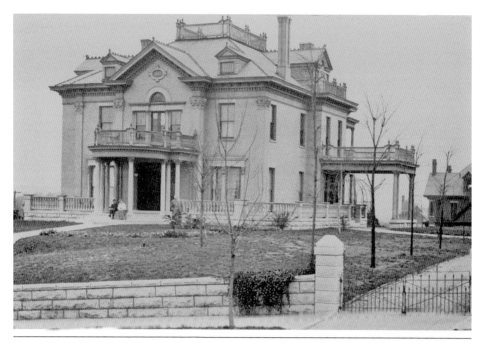

This home of yellow brick at 950 Vine Street, which serves as a Masonic temple, was once the residence of Jo Conn Guild, a proponent of electric power in Chattanooga before the days of the Tennessee Valley Authority dam-building projects. President of the Tennessee Electric Power Company (TEPCO), Guild allied with men such as Charles James to build the Hales Bar Lock and Dam in 1913 in order to harness the force of electricity through water-powered generators.

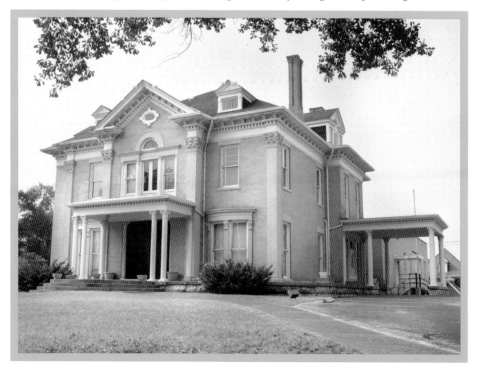

The road that originally went east from downtown Chattanooga to Missionary Ridge and on to the Brainerd Mission went past the McCallie farmstead, the home of one of Chattanooga's outstanding pioneer families. Over time, McCallie Avenue became a boulevard of prestigious homes and notable architecture. Though most of the housing has been demolished, the old Henry Bond home is a reminder of an eye-catching brick home that was built to conform to a narrow lot.

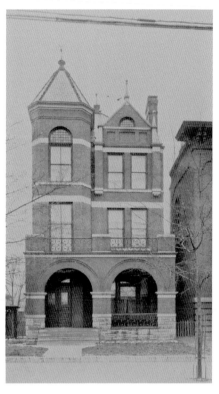

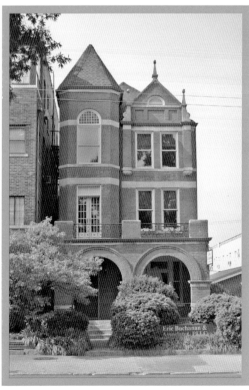

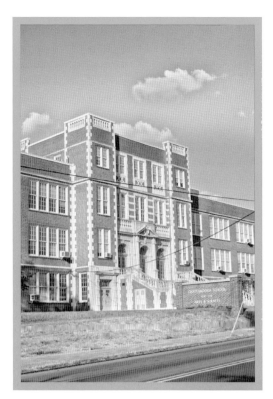

Situated between the Tennessee River and the Chattanooga City Cemetery on East Third Street, Chattanooga High School is another example of R. H. Hunt's design successes. With its university Gothic architecture, it has served school children for 85 years. Serving today as a magnet school with kindergarten through twelfth grade, it was a predominantly African American school called Riverside High School in the 1960s and 1970s, granting a diploma to world-famous actor Samuel L. Jackson.

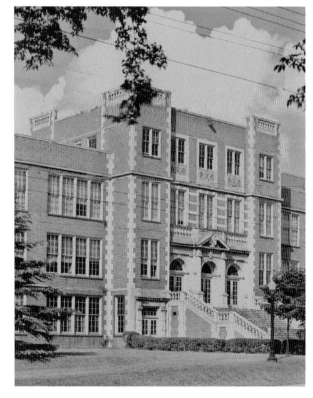

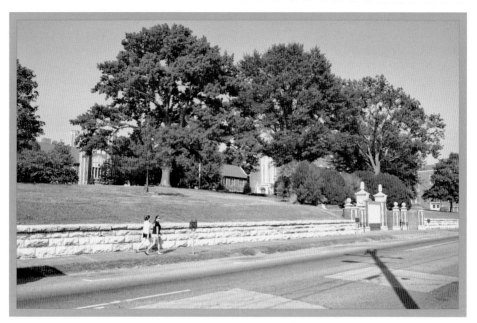

A large swath of trees and lawn fronted by a limestone wall on McCallie Avenue depict the site of "Old Main," the original building on the campus of the University of Tennessee at Chattanooga. This huge structure housed classrooms, living spaces, and the library when the college, known then as Chattanooga University, opened in 1886. In 1917, the school decided to demolish Old Main and construct buildings on a smaller scale arranged around the current open lawn.

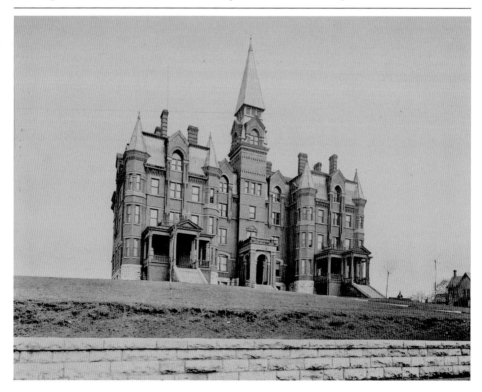

LANDMARKS AND ATTRACTIONS

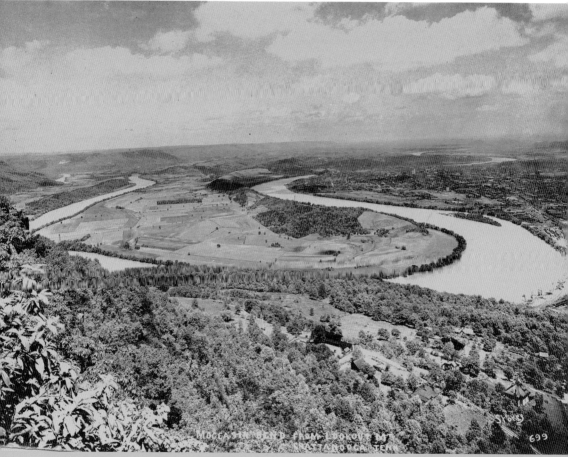

Moccasin Bend, so named because the river's bend resembles the outline of a foot, is one of the most photographed views in the South. This photograph from Lookout Mountain looks north toward Signal Mountain in the distance; the city of Chattanooga is to the right. Human habitation on the bend is thousands of years old. To honor the area's history, Congress, with legislation passed in 2003, declared that much of the land be added to the Chickamauga and Chattanooga National Military Park in 2004.

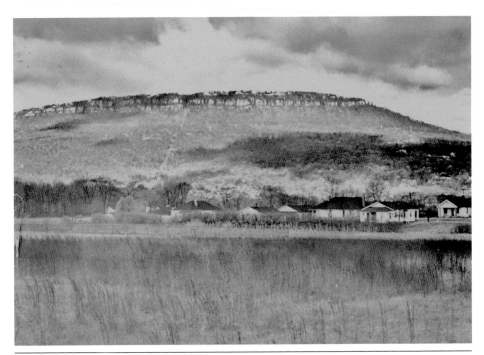

Lookout Mountain is one of Chattanooga's enduring landmarks. Essentially a long plateau stretching from Alabama and into Georgia, its northernmost tip protrudes into Tennessee. Following the Civil War, the mountaintop served as a refuge from the summer heat and epidemics such as the yellow fever scourge of 1878. By the 1890s, hotels attracted tourists, and two rail lines ascended its slopes. Today the mountain features beautiful neighborhoods and is home to some of the city's wealthiest residents.

LANDMARKS AND ATTRACTIONS

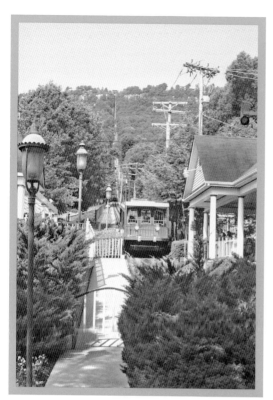

The Lookout Mountain Incline Railway opened in 1895 and rises in a steep line to the top of Lookout Mountain. A grand hotel, the Lookout Inn, stood at the top to receive visitors until it caught fire and burned to the ground in a spectacular fashion in 1908. The rail line remains one of Chattanooga's most enduring tourist attractions, climbing the 72.7-percent grade regularly from the St. Elmo neighborhood at the foot of the mountain.

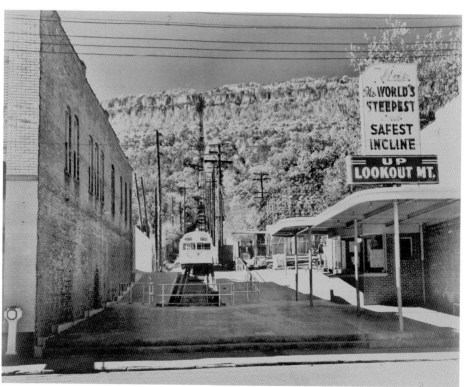

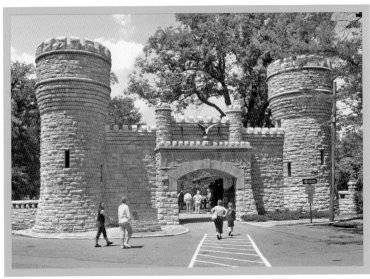

Point Park is part of the Chickamauga and Chattanooga National Military Park that commemorates the struggle for Point Lookout during the Civil War. Located on the very northern end of Lookout Mountain and commanding a vista that belonged to Confederate forces, it offers the visitor a grand opportunity to visualize the entire theater of war as it would have been seen by soldiers on this mountaintop from Wauhatchie below to Missionary Ridge in the east.

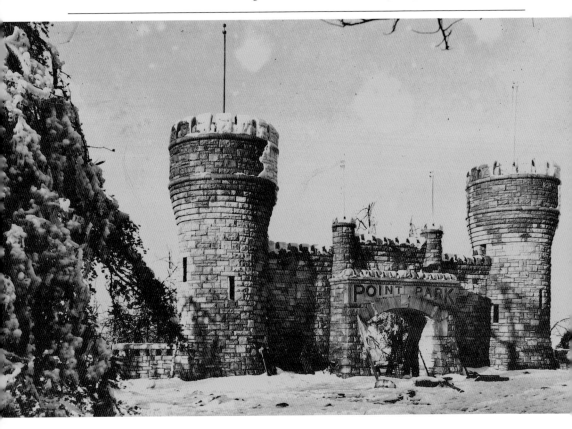

LANDMARKS AND ATTRACTIONS

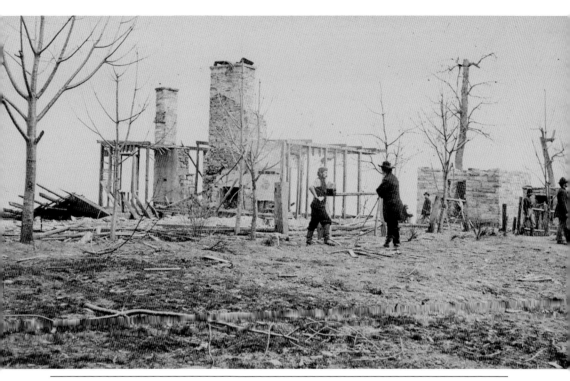

Thomas Cravens was an enterprising ironmaster who built the Bluff Furnace downtown on the Tennessee River. His house was in the midst of the Battle above the Clouds and is considered the oldest structure on Lookout Mountain. The historic photograph shows the rebuilding of the destroyed house, which was made part of the Chickamauga and Chattanooga National Military Park in 1896 and is open for tours during select times of the year.

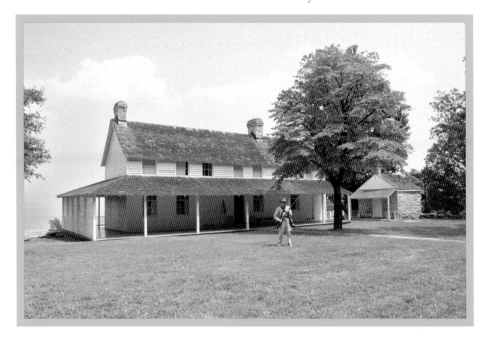

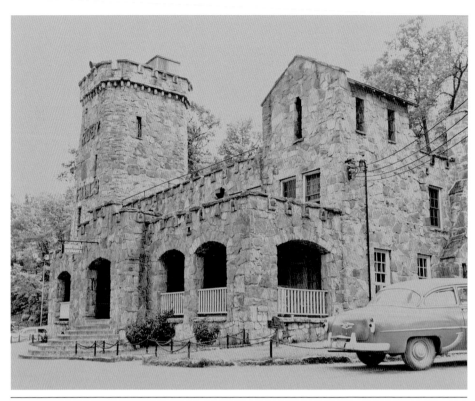

The eastern Tennessee mountains are riddled with caves, and one of the most famous in the South is Ruby Falls. After the entrance to a cave on Lookout Mountain had been closed, Leo Lambert, a dedicated spelunker, drilled into the mountain looking for a new opening and discovered a 145-foot underground waterfall. Named for his wife, Ruby, he opened this roadside attraction in 1930, complete with a limestone entry building modeled after a 15th-century Irish castle.

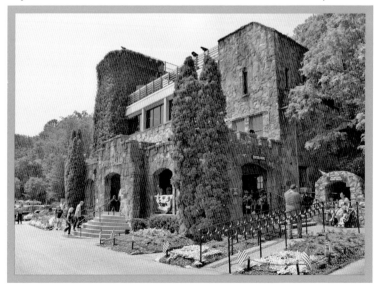

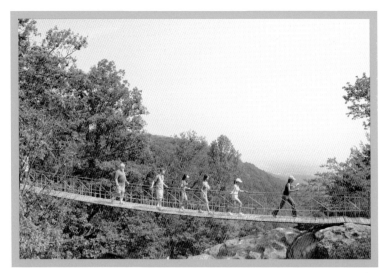

Featuring highly unusual rock formations such as Fat Mans Squeeze and man-made attractions like the Swinging Bridge, Rock City was the inspiration of Garnet Carter, who developed this site on Lookout Mountain. His wife, Freida Carter, added gnome-like statues to create the impression of a fairyland. Aided by the new Dixie Highway, a national highway that ran through Chattanooga, Rock City opened in 1932 and became famous because of barn roofs displaying the words "See Rock City."

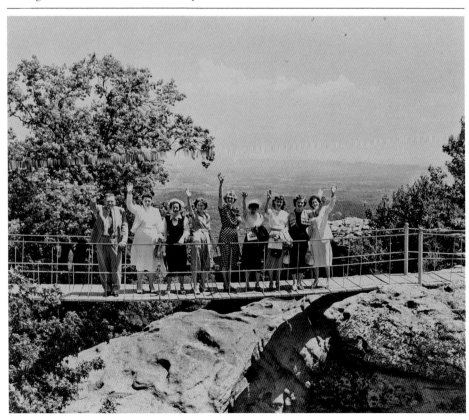

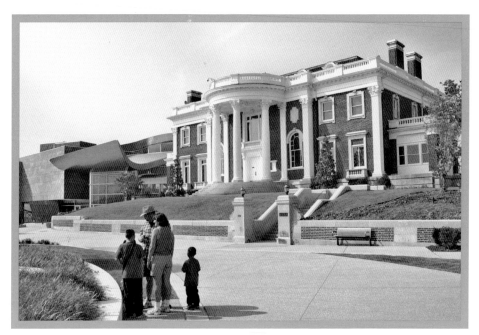

The Hunter Museum of American Art surrounds the classical revival architecture of the Faxon House. Built in 1904 where a Confederate battery once stood, the mansion on the bluff eventually was the home of George Hunter, chairman of the board of the Coca-Cola Bottling Company. In his will, Hunter deeded the mansion to the Chattanooga Arts Association, which opened the museum in 1952. Visible to the building's left (above) is the sleek, new, metallic addition to the facility.

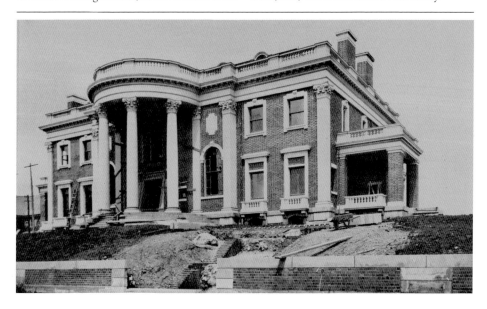

LANDMARKS AND ATTRACTIONS

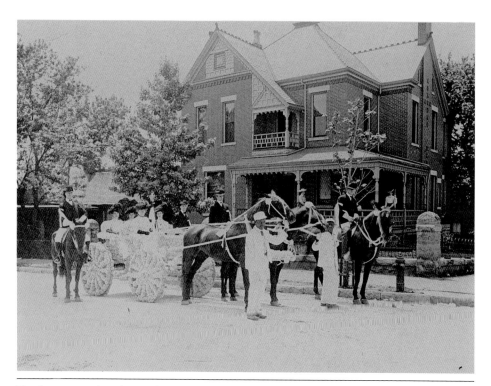

This house at High and Second Streets is one of the few remaining structures of a once-prosperous neighborhood, as evidenced by the historic photograph of the flowered carriage ready for the spring festival. Now part of what is called the Bluff View Art District, the High Street structure is the site of the Houston Glass Museum, with its extensive collection of Depression glass that once belonged to the remarkable "Antique Annie," as Anna Safley Houston was known.

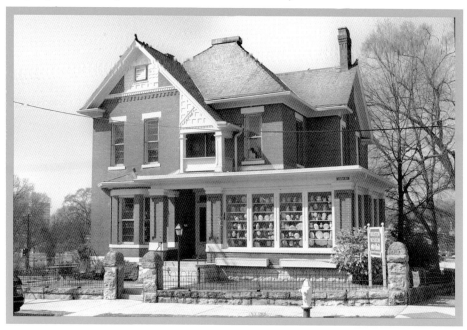

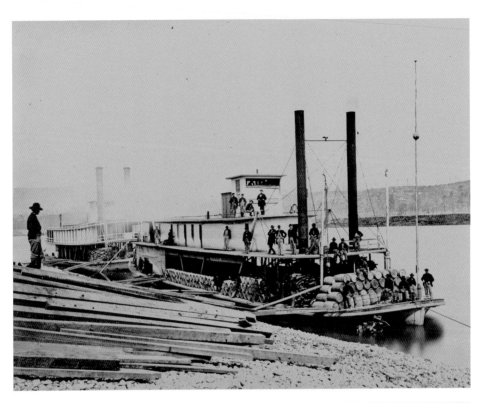

The Tennessee Aquarium (right) rises above the boy who gazes at the water on the plaza by the waterfront attraction. Standing on Ross's Landing, the aquarium sparked a renaissance of activity in a slumping downtown Chattanooga when it opened in 1992. Before it became a site for the commercial water trade, as in the Civil War–era photograph above, the original Ross's Landing was a good place to cross the Tennessee River into the Cherokee Nation after John Ross started operating his ferry in 1815.

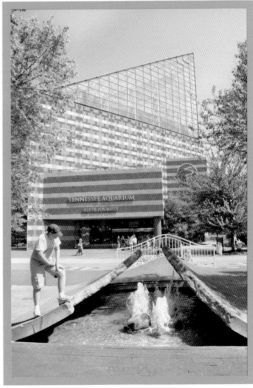

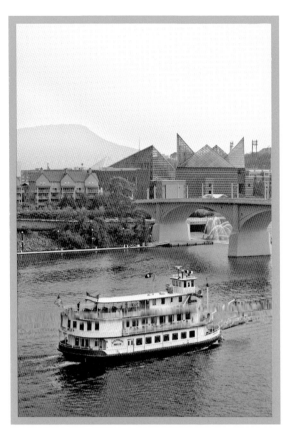

Chattanooga and the Tennessee River are inextricably linked, so it is no surprise that residents and visitors alike enjoy the water, if for nothing other than a pleasure cruise. Chattanooga has usually had a reminder of the steamboat era docked near Ross's Landing, whether it was the *Gordon Greene* many years ago or the *Southern Belle* today. The *Belle* daily plies the waters of the river, serving food and scenery, and sounding its whistle as it sails by.

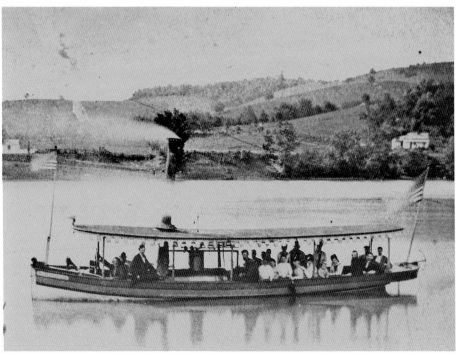

Missionary Ridge has a number of markers and cannons planted along its long crest road memorializing the struggle that took place between the North and the South in November 1863. This area, designated as the Bragg Reservation, marks the scene of the intense fighting that took place as thousands of Confederates under Gen. Braxton Bragg lining the ridge failed to hold off a determined Federal assault. The Illinois Monument still stands today, though the companion observation tower has been dismantled.

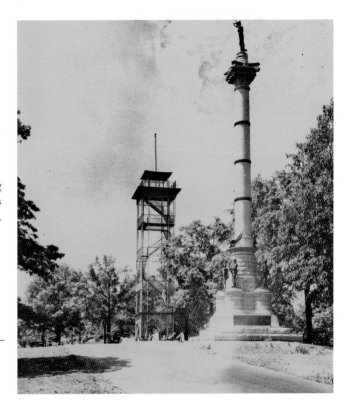

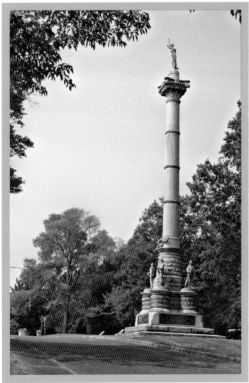

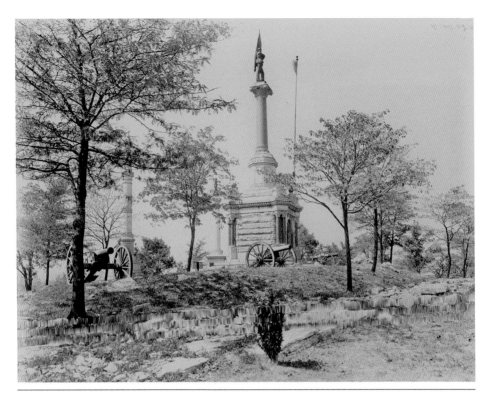

Orchard Knob, or Orchard Bald as it was originally called, was the pivotal observation spot for Gen. Ulysses S. Grant and his officers in November 1863. Besieged by hostile Confederate forces in Chattanooga, the Union launched an attack against Mission Ridge from the knob in order to drive the rebels off the high point and back into Georgia. With Gen. William Tecumseh Sherman leading the left flank, the Union carried the day with a brave assault straight up the slope.

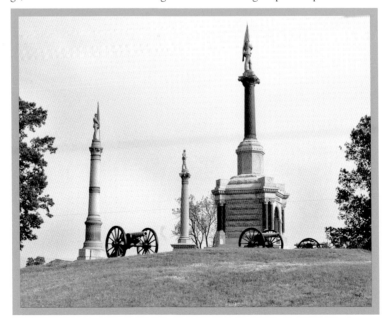

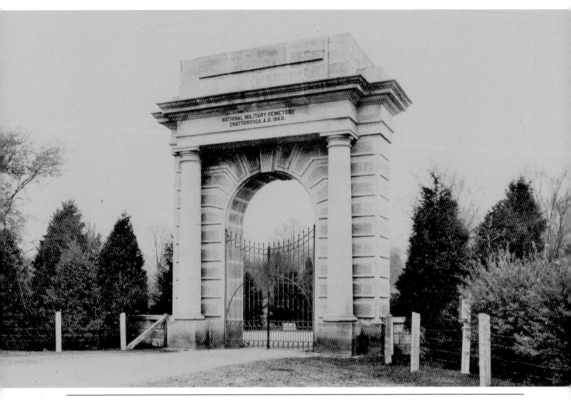

These iron gates still swing open beneath the grand arch above them, though they serve only a symbolic purpose. The original entranceway into the National Cemetery, with its fields of war dead, this structure is enclosed inside the boundaries of the property. The common entrance is on the opposite side on Bailey Avenue, where a guardian's house is located. Behind the camera and facing the old cemetery gates is a modern pavilion commemorating the armed forces.

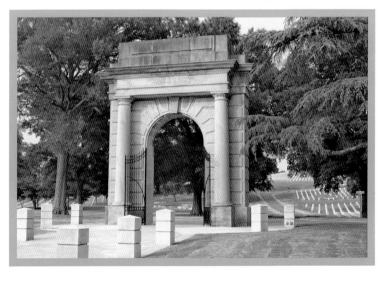

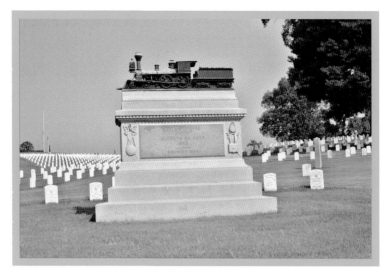

The National Cemetery holds many a story, but none is as well known as that of Andrew's Raiders. The iron train replica on the stone monument commemorates the journey of the Union spies to Kennesaw, Georgia, on a mission to steal a train and raise havoc with the railroad. Though they failed in their efforts, they are remembered partly through Buster Keaton's silent movie, *The General*, and a later Disney film as well.

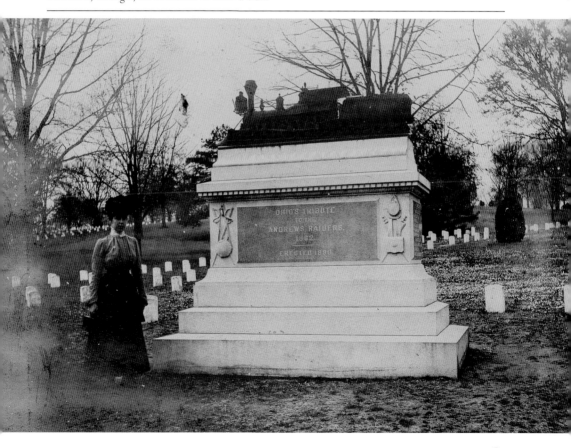

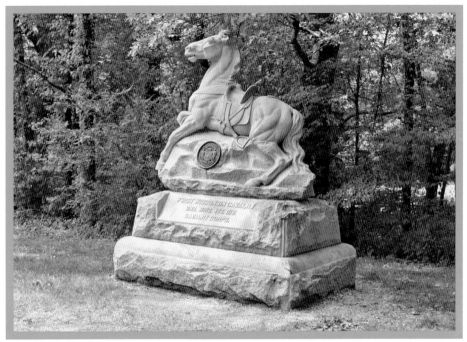

The Chickamauga and Chattanooga National Military Park was dedicated in 1895 after years of effort by both sides to create a memorial to the battle at Crawfish Springs. As the first military park in the nation, it drew the attention of many people who wanted to dedicate markers to units that fought on this ground. The Wisconsin monument of the riderless horse is a finely realized example of the numerous figurative works that can be seen throughout the park's acreage.

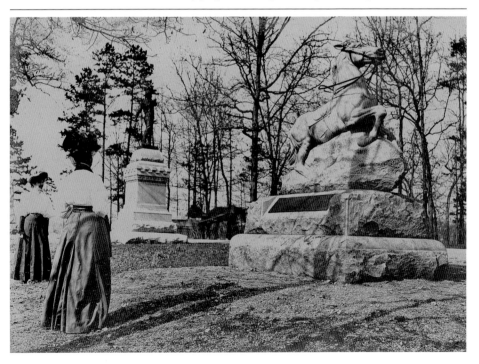

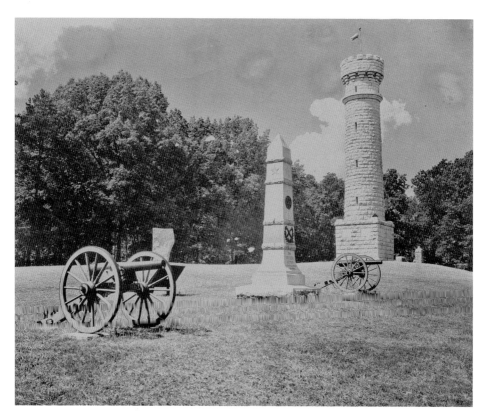

Wilder Tower stands on a high piece of
ground at the Chickamauga and Chattanooga
National Military Park and signifies the
action of a day that was a stunning defeat for
the Union forces. Gen. John T. Wilder, who
had earlier shelled the town of Chattanooga
from across the river, would decide to return
here after the war concluded. His choice
was an intelligent one, as he would become
a successful Chattanooga businessman and
the mayor of the city as well in 1872.

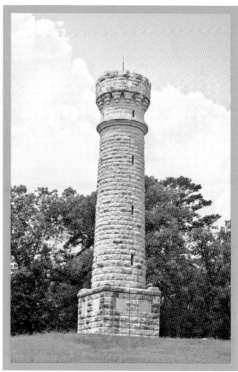

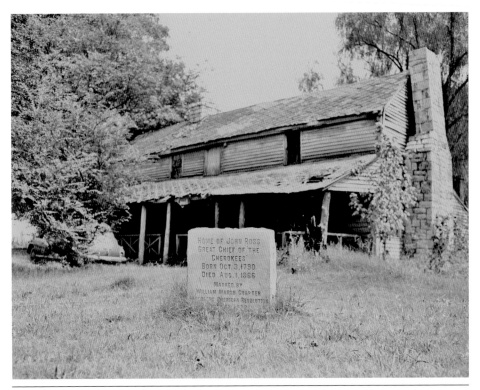

John Ross is an impressive figure in 19th-century American history. Principal chief of the Cherokees for decades, Ross guided his people through their trials before and after the tragic Trail of Tears. The founder of Ross's Landing—essentially a river crossing and store—he grew up in this house built in 1797 by his grandfather, the Scotsman John McDonald. The house has been moved about 100 yards from its original site for purposes of preservation in Rossville.

ABOUT THE AUTHOR

William F. Hull has been working in the history museum field for the last 25 years. As staff photographer for the Atlanta History Center, he was involved with the preservation of historic images and served as curator for several exhibits dealing with the cultural importance of photography. With a background in art history, Hull is conversant with the many facets of photography and has a particular interest in 19th-century photography, especially daguerreotypes. A native of Chattanooga, he attended Baylor School and graduated from Vanderbilt University. As the collections manager at the Chattanooga Regional History Museum for five years, Hull was the curator of two exhibits and oversaw the care and development of the museum's permanent collection. In 2006, he wrote the successful *Historic Photos of Chattanooga*, a look at 100 years of Chattanooga history through black and white images, many of them published for the first time. He lives in the family home in North Chattanooga with his wife, Eleanor, and their two sons.

DISCOVER THOUSANDS OF LOCAL HISTORY BOOKS FEATURING MILLIONS OF VINTAGE IMAGES

Arcadia Publishing, the leading local history publisher in the United States, is committed to making history accessible and meaningful through publishing books that celebrate and preserve the heritage of America's people and places.

Find more books like this at
www.arcadiapublishing.com

Search for your hometown history, your old stomping grounds, and even your favorite sports team.